watercolours in a weekend
LANDSCAPES

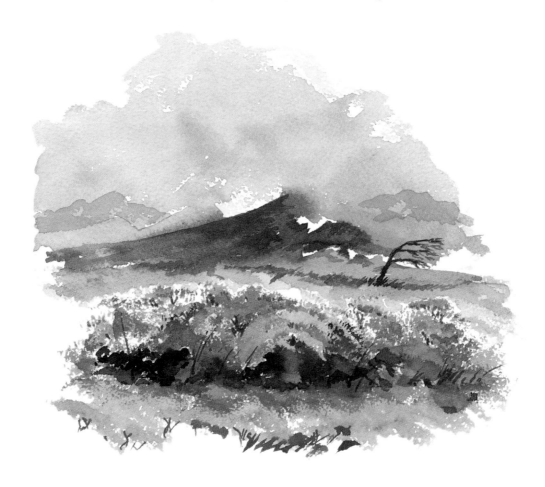

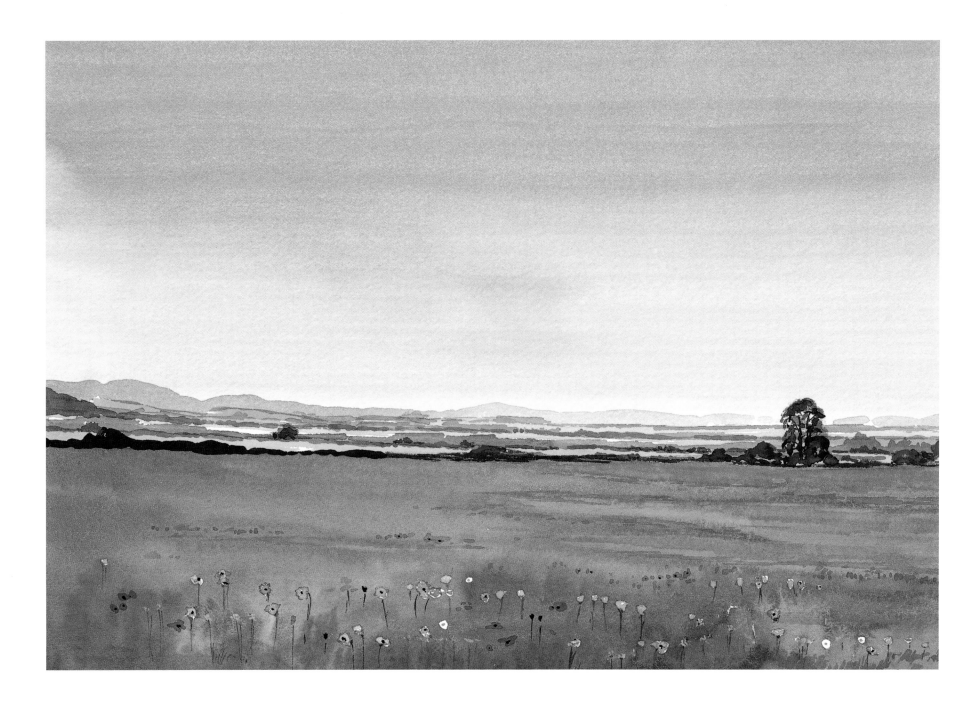

FRANK HALLIDAY

watercolours in a weekend
LANDSCAPES

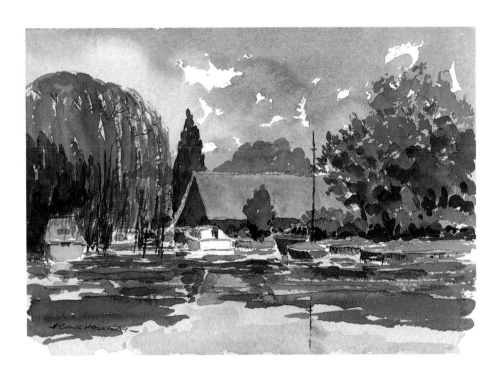

David & Charles

DEDICATION

I dedicate this book to all the ladies in my life; my dear departed mother, Hannah, my lovely wife Carol, my two lovely daughters Rachel and Jennifer, my one-year-old granddaughter Laura. Add to this my three-year-old grandson Henry.

A DAVID & CHARLES BOOK

First published in the UK in 2003

Distributed in North America
by F&W Publications, Inc.
4700 East Galbraith Road
Cincinnati, OH 45236
1-800-289-0963

A catalogue record for this book is available from the British Library.

ISBN 0 7153 1473 4 hardback
ISBN 0 7153 1538 2 paperback (USA only)

Printed in Singapore by KHL Printing Co Pte Ltd
for David & Charles
Brunel House Newton Abbot Devon

Commissioning Editor Sarah Hoggett
Senior Editor Freya Dangerfield
Art Editors Brenda Morrison, Sue Cleave
Production Controller Kelly Smith

Visit our website at www.davidandcharles.co.uk

David & Charles books are available from all good bookshops; alternatively you can contact our Orderline on (0)1626 334555 or write to us at FREEPOST EX2110, David & Charles Direct, Newton Abbot, TQ12 4ZZ (no stamp required UK mainland).

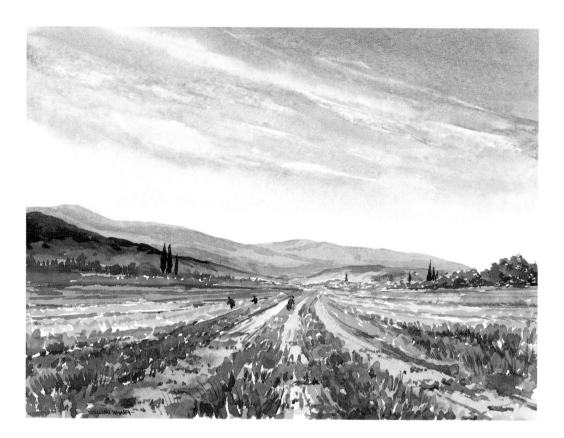

Above: A Corner of Provence, France
Page 2: Poppy Fields, Norfolk
Page 3: Broads Backwater, Wroxham

contents

introduction

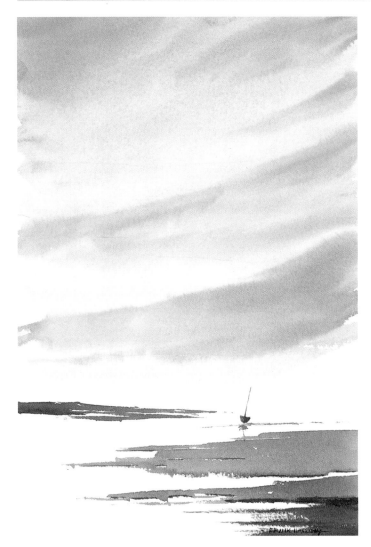

BIG SKY AND LOW TIDE

Well done! You have just taken your first step down the magical road of painting luminous watercolour landscapes, full of light and contrast. The aim of this book is to tempt newcomers, beginners and improvers to gain confidence and acquire new skills to produce pictures they do not realize they are capable of before they start.

Some people believe that painting is too difficult for them, but I know that once you understand the basic equipment and techniques, you can paint a picture you will be pleased with – even if you have never picked up a brush before – and once you get started there is often no stopping.

how to use this book

The first part of the book explains and illustrates the materials and basic techniques that you need to get started. The second part is divided into subject matter – skies and clouds, water, mountains and lakes, trees and foliage, buildings and textures, reflections, winter landscapes and summer landscapes. For each subject I have provided easy-to-follow, step-by-step exercises that can be practised on Saturday to help you to gain confidence before tackling a more detailed Sunday painting. For this project, I have provided you with a large-scale outline sketch – copy or trace it, and you will be ready to paint along with me.

In my many years of tutoring I have found the main stumbling blocks for beginners to be picture composition, scale of items and subject matter, which together cause more people to put their brushes away and stop painting than anything else. Each of the various exercises here demonstrates, in a straightforward and practical way, how to use the techniques and materials to improve your skills and make your pictures even better. I believe that you will be amazed at the success and improvement of your painting skills.

what to paint?

Most of us only see things at eye level. Art helps you see life differently. Take the time to look around, upwards to see the tops of buildings and trees, or to the more distant fields where tones and colours diminish as they get further away and give a wonderful sense of recession.

Inspiration is all around you, wherever you are. Don't feel you have to paint what other people paint – remember that painting is a matter of personal choice. What you paint is up to you – it could be an old barn door or an old water butt. When you have decided, ask yourself the question, 'What makes me want to paint it?', and then concentrate on that and emphasize that particular aspect. This is what will make your work special and unique.

enjoying painting

Never lose sight of the fact that painting is fun and that we all have glorious failures from time to time; remember, however, that it is only a piece of paper and your next picture may be the masterpiece we all strive to paint! But please be warned that painting can become addictive and a joy for many, many years, as it is something you can do no matter how young or old you are. But now it's time to stop the chat: get your materials and let's start painting.

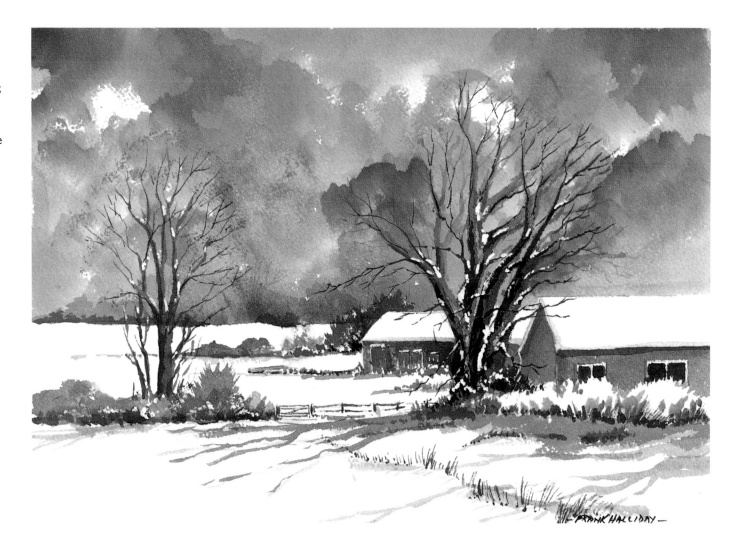

WINTER AT MORRISON'S TIMBER MILL, FELTHORPE, NORFOLK

painting materials

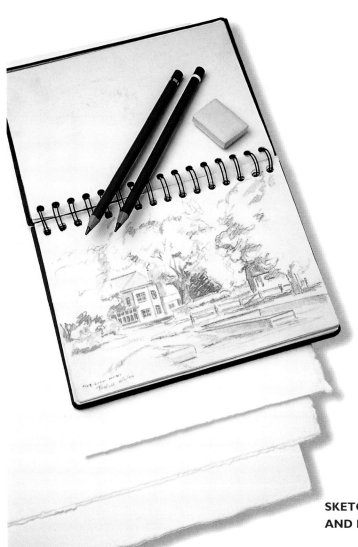

Once you have decided on what to paint, you need the right equipment. I know what it feels like to wander into your local artist-material store: you are faced with so great a choice of brushes, paints, papers, pencils, erasers and so on, that you feel like rushing out again. Do not despair: I have listed the items I use that will cover any type of painting challenge. Select items that you feel comfortable with, and add special items of your own. My students come from all walks of life, and my advice to them all is, 'buy the best you can afford'.

sketchbook
You will need a small sketchbook. You may feel a bit inhibited at first getting a sketchbook out in front of others, so try a smaller one such as a 150 x 100mm (6 x 4in) that you can slip into your pocket alongside your pencil and eraser. When you see something you like – it can be a landscape view or a close-up detail, such as a gate or a lamppost, just open your sketchbook and do a quick drawing. Try to do it in five minutes. Don't overdo it – don't put every blade of grass or every shop window in, but

**SKETCHBOOK
AND PAPERS**

use a minimum of lines. Then try another one, turn round and sketch from a different angle or a different position. Sketch anything – and keep going till you have filled the book.

If it's a day when the light makes the colours particularly special, then make a note of them so you have a record when you go home to paint. A sketchbook refreshes the memory and can bring back the experience of how you saw it at the time.

Sketching can be a real joy, and once you have got used to using a small sketchbook you may want to progress to using something larger. Choose whatever is right for you.

pencils
You will need a soft pencil for sketching and underdrawing. Pencils are graded from hard (H) to soft (B). Soft leads are available from 2B up to 10B (softest). I use a 4B, which gives a nice light stroke for sketching and a heavy stroke to fill in shadows. The softness of the graphite does not damage the delicate watercolour paper surface, which is very important, as when you start to paint any damage would show.

watercolour papers

Paper can be purchased in large single sheets, spiral-bound pads, or blocks, which are gummed all round the edges and do not require stretching. Watercolour paper is classified by texture and weight.

Texture is the feel of the painting surface. The three textures are:

HP (hot-pressed)
This has a very smooth surface and is ideal for very fine, detailed work.

NOT (not hot-pressed) or cold-pressed
This has a slight texture or tooth, and is a good all-round surface for general painting.

Rough
This has a greater tooth, which is lovely for heavy washes. Colours that granulate will settle in the wells of the textured surface to give a special effect.

Weight is calculated and shown as the weight per ream (500 sheets) of paper. The most popular weights are:

180gsm (90lb)
I feel this is too thin for good watercolour washes, but it is suitable when washes are not being employed.

300gsm (140lb)
This weight is the one most widely used. This and the lighter weights need to be stretched if you are using a wash technique.

400–600gsm (200–300lb)
These are the heavyweights of the paper world. They do not need stretching and will stand any amount of rough treatment.

As a guide, the heavier the paper the more expensive it is. I mostly buy the heavier weights and choose a Rough surface. I can simply tape it down to my board with masking tape and I'm ready to go. If the painting turns out to be a total disaster (we all have them!), I just turn it over and paint on the other side.

Throughout this book I use 600gsm (300lb) Winsor & Newton Lana Aquarelle Rough and Saunders Waterford 600gsm (300lb) Rough papers, both of which I find suit my style of painting. They absorb the water and don't buckle or distort when I apply really wet washes to their surface.

At this thickness I have no need to stretch the paper, which is a process that prevents thinner papers from cockling when water or washes are applied. Stretching paper involves soaking the paper and fastening it onto a board with gummed tape around the edges, and laying it flat overnight until perfectly dry, as shown right.

stretching paper

step 1

There are two ways of wetting the paper. You can soak it in the bath for a few minutes, then shake off the surplus water before positioning it on your board, or you can place the dry paper on the board and wet it all over with a sponge or damp cloth.

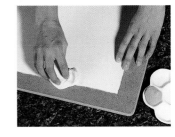

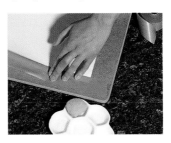

step 2

To stick the paper down, you must use gumstrip, not masking tape or Sellotape. Cut the strip into the lengths required, wet it with a sponge or damp cloth and stick it down, overlapping the paper by at least 1.5cm ($\frac{1}{2}$in). Start with the two longer sides.

step 3

Finish with the two shorter sides, then leave the paper to dry naturally. You can place it near the radiator to speed up the drying, but don't use a hairdryer, as it can cause the gumstrip to tear away from the paper.

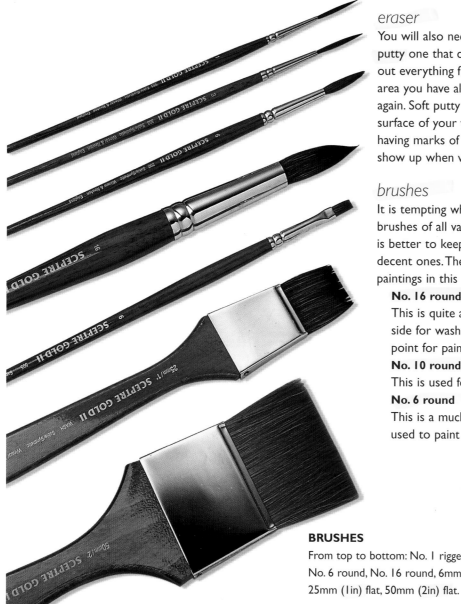

BRUSHES

From top to bottom: No. 1 rigger, No. 3 rigger, No. 6 round, No. 16 round, 6mm (¼in) flat, 25mm (1in) flat, 50mm (2in) flat.

eraser

You will also need an eraser. Choose a soft putty one that can be shaped. Use it to take out everything from a thin narrow line to an area you have already shaded to make it clear again. Soft putty erasers are gentle on the surface of your watercolour paper and avoid having marks of lots of erased lines, which will show up when water is applied.

brushes

It is tempting when you start to get a fistful of brushes of all varieties and shapes; however, it is better to keep it simple and to choose a few decent ones. The brushes I have used for the paintings in this book are:

No. 16 round

This is quite a large brush. You can use the side for washes, and it also gives a beautiful point for painting detail.

No. 10 round

This is used for mid-size washes and details.

No. 6 round

This is a much smaller brush and can be used to paint really fine detail.

No. 3 rigger

This was originally designed for depicting the rigging on ships. It has long hairs – hold it with the tip of the handle of the brush and use it in a flowing movement to paint thin flowing lines such as grasses, tree trunks, branches, twigs, and telegraph wires.

12 or 6mm (½ or ¼in) flat

This is similar to a chisel brush and can be used to paint more linear subjects such as brickwork or the edges of buildings, pantile roofs, and fence posts.

23 or 50mm (1 or 2in) flat

This can be used for details.

Brushes are made of various materials – either natural or synthetic, or a mix of the two. The finest quality is Kolinsky sable, which comes from the far reaches of Siberia. The animals are hunted for their skins and these brushes are made from their tails, which are classed as a waste product. 95 per cent of the tails that are sold to make brushes are rejected, which is one of the reasons why they are so expensive. Sable has the advantage of holding more water in the brush, which means you can go on for longer with a wash.

A mix of sable and synthetic bristle gives you the advantage of both the absorption of the sable and the lovely spring and good point of the synthetic fibres, at a more affordable price.

Finally, there is the totally synthetic brush, which is the least expensive. Synthetic bristles can also give you a lovely point.

palette

The secret of success for any watercolour painting is in the use of colours, and the palette is where you mix them. I work with an inexpensive plastic palette. This has 15 square boxes around the edge, which I use to squeeze the individual tube colours into, and five large areas in the centre for mixing washes and different colours together. There are three corner boxes that are double the size of the others, which I find very useful for placing my most frequently used colours, and also saves me from having to fill them up too often.

paint

It is tempting to buy the cheapest paint available, but I believe this is a mistake. If you want to produce some good work you've got to have good paints – whether artists' or students' quality, always buy the best you can afford. Throughout the book I use Winsor & Newton Colart artists'-quality tube paints.

There are two types of watercolour paints – blocks of paint known as pans, and tubes of paint. Both need water added to make them ready to apply to the paper, although colours can be used straight from the tubes at times to create particular effects.

Which type you use is a personal choice. With tubes you squeeze out the pigment onto a palette and add water for instant colour. With pans you mix water on them with the brush and then use them straight onto the paper or mixed with other colours on your palette.

I place the colours in a set order on my palette, and I strongly recommend you set yours out in a fixed format. When you get to know where your colours are, you can concentrate fully on your painting. Some time ago I introduced a new colour to my range, and I was dipping in the wrong paint for days because I had moved some of them along one place. My favoured colours, listed in the order I place them on my palette, are:

· **raw sienna**
· **cadmium lemon**
· **cadmium yellow**
· **burnt sienna**
· **raw umber**
· **burnt umber**
· **light red**
· **alizarin crimson**
· **Winsor red**
· **Payne's grey**
· **cobalt blue**
· **Winsor blue green shade**
· **Winsor blue red shade**
· **French ultramarine**

You will see that, although I am a landscape painter, I do not have a readymade green. I find that mixing my own gives me much more variety. It is easy to fall into the trap of overusing a green if it is readily available on your palette – a good look at a landscape shows just how many greens there are.

To appreciate the versatility of your palette, choose one colour; make a mark on a piece of

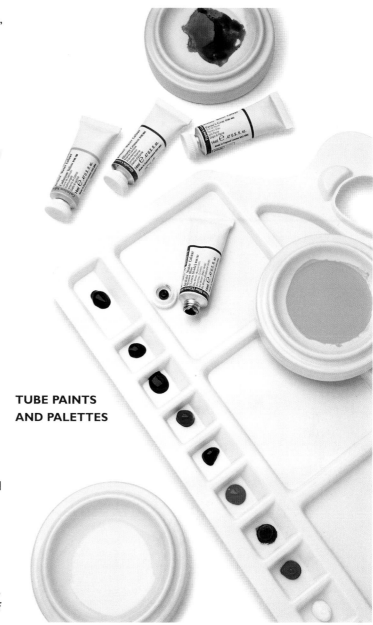

TUBE PAINTS AND PALETTES

paper with it. Add more water to the paint on the palette and make another mark alongside your first. Do this about six times, adding more water each time until you get a thin dilution: as you add more water you get a paler and paler colour. Do the same with another colour. In this way you can make up a reference chart for yourself – number each mark you make and describe which colour and how much water you added to create the particular tone.

Then try adding two colours together and repeat the exercise. In this way you will get to know how your colours perform. You will be amazed at the variety of tones you can get from what seemed to be a small colour range.

watercolour mediums

An exciting range of watercolour mediums are available, designed to assist you in achieving special effects. Depending on the type, they can be added into your mixed wash or applied directly to the paper surface.

masking tape and gummed tape

Masking tape is used for taping down heavyweight papers; and on completion of your picture it can be peeled off to leave an attractive white border. Gummed tape is for securing lighter-weight papers to the board to prevent them curling up, or 'cockling', each time that a wet wash is applied.

masking fluid and mapping pen

These items are very useful for retaining highlights in an area of picture that is difficult to paint round. Fine lines of masking fluid, which is a liquid latex, can be applied with a mapping pen.

Larger areas can be applied with an old brush, but heed my warning – do not use your best brushes for this operation! Wash out the brush immediately after use, or the masking fluid will set solid. However, you can peel dried masking fluid off mapping nibs.

WATERCOLOUR MEDIUMS

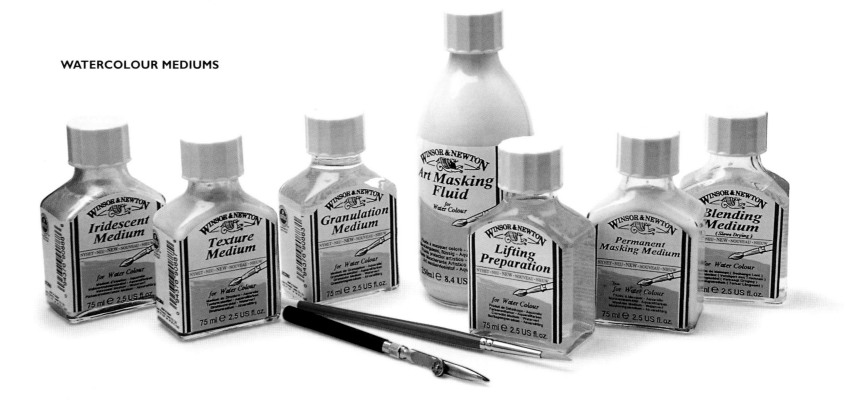

plywood board

This is for supporting the paper and stretching it prior to painting. The size needs to be about 50mm (2in) larger all round than your sheet of paper, to allow room to tape or stick down the paper. My boards are 660 x 510 x 6mm thick (26 x 20 x ¼in thick), and I have about ten of them with paintings at various stages of completion.

sponge

This is the craft-type sponge available in artist-material shops and is used for sponging out areas of colour, to represent clouds in a sky, textures on trees or old doors, for example.

craft knife and kitchen tissues

Both items are extremely useful – the knife is used for sharpening pencils, cutting masking tape or gummed tape. You will find tissues invaluable for, amongst other things, lifting off colour, mopping up, drying brushes and cleaning palettes.

water containers

Because I paint on location most of the time, I use a couple of collapsible plastic pots, which are very lightweight to carry. I use one for rinsing the brushes and the other one for mixing the washes. This is a small tip with massive effect, as clean water is essential for bright, clear landscapes!

hair dryer

This will speed up drying time on washes if you are the impatient type, like I am.

enthusiasm and sense of humour

Both items are needed in great quantities.

ADDITIONAL MATERIAL
left to right: sponge, collapsible water container, craft knife, masking and gummed tapes.

working outdoors

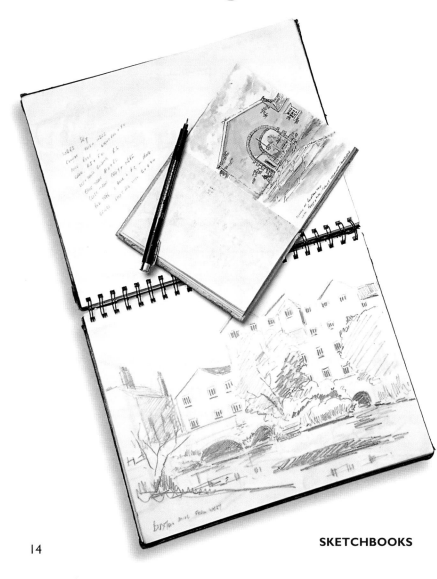

If you have not yet tried working on location, you are in for some inspiring times ahead.

For many years I have carried a pocket-size sketchbook in addition to the larger A4 size that I use for more detailed work. The secret is to sketch anything and everything, which improves your skills in capturing the moment with a few well-chosen lines. Do not worry about whether your sketch will form the basis of a masterpiece: you will find that you can use a simple study of a subject and incorporate it into a more detailed work.

what to sketch?

I sketch cars, motorcycles, shops, animals, clouds, boats, mountains, river estuaries, castles, churches, cafés, people, markets, airports, harbours, beaches – the list of subject matter is endless. I must admit that I have not used everything I have sketched, but the sketches have given me so much material and, more importantly, so much pleasure – the scenes immediately bring back the day and place, which makes for very happy memories.

What attracts me to a subject? It could be a reflection, a strong cloud formation, a silhouetted building or a tree that captures my eye. The most important thing is to focus upon that item and ensure that everything around it is rendered subordinate to it. Therefore you can be selective in what you include, can leave

out confusing detail and do not try to include every last feature, or you will be disappointed in your effort.

In my view, the play of light and shade is an element of the subject matter where you can make the most impact and give your sketch, and eventually your painting, something special. Try to put the lightest lights against the darkest darks. Look for these aspects in your subject, and then emphasize the difference.

making notes

There are several methods of recording the colours you observe on location. Some artists prefer to note the names of the colours on the actual sketch, for example sky: ultramarine; clouds: raw sienna with ultramarine, plus burnt umber under the clouds for greys; grass: cadmium yellow plus Winsor blue red shade. Personally, I avoid this method, as it is often difficult to see the actual sketch for all the notes when referring back to it.

Another method, if you know your palette colours well and the position you place them on your palette, is to give them a number code from left to right on your palette, and simply put the number code on your sketch. This keeps it relatively clean and easy to decipher.

The method I feel most comfortable with is to use the facing page of my sketch and annotate this with any colour notes and points

SKETCHBOOKS

of importance, such as the time of day and the direction of light. I may note the weather conditions, such as 'storm coming from the west' or jot down ideas, such as 'try this as a winter scene' or 'with puddles using reflections'. Notes that are personal to me, will refresh the feeling of the day.

finding a viewpoint

Do not accept that your chosen viewpoint is the only one. Take time to walk around, try different angles, even turn in the opposite direction – there may be a terrific picture behind you!

the end result

When you finally decide to turn one of your sketches into a full painting, and if you have taken into account some of my suggestions, the chances are that you will be delighted with how much your work will improve. If you look at your finished work and the hairs on the back of your neck stand up, you will know it is a winner!

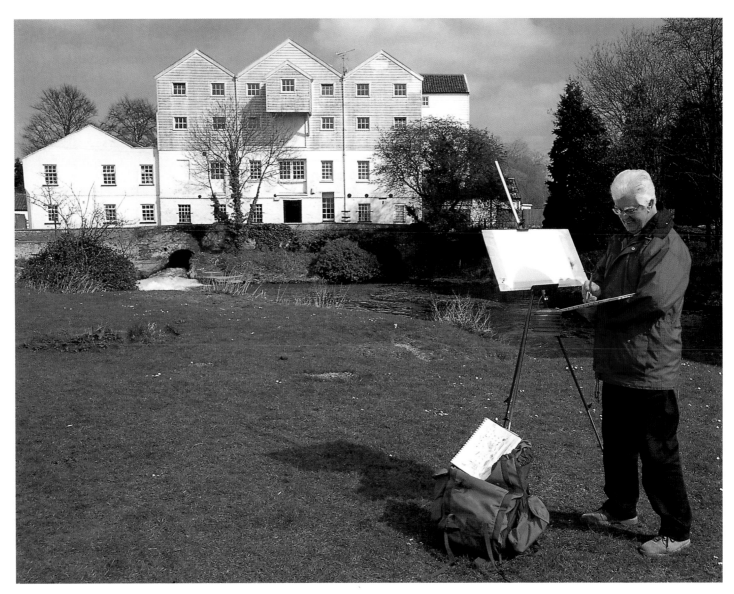

MYSELF, PREPARING TO PAINT THE PICTURE ON PAGE 72

basic techniques

washes

Before we take our magical watercolour journey to the projects and pictures just waiting to be painted, we need to build confidence in the basic watercolour techniques. The first of these is washes – if you master washes, you have mastered the essence of pure watercolour. When you analyse most watercolour pictures, they represent a series of washes, either single or layered, or blended with other washes to create a transition of colour. Sometimes they are wet in wet or wet on dry, giving you endless possibilities. Take these basic tips with you throughout the book, and you will be rewarded endlessly in your future pictures.

flat wash

In this exercise I mixed a quantity of cadmium yellow and Winsor red.

Starting with the paper angled at approximately 15 degrees, fully load a No. 16 round brush with the wash, then move the brush horizontally back and forth across the paper, starting at the top and making each subsequent stroke overlap

the previous one, until you reach the bottom of your paper. Leave the wash to dry and do not go back into the colour to improve it – you never do!

graduated wash

Most skies recede and lose tonal value as they approach the horizon. Mix a wash of Winsor blue red shade and apply with horizontal brushstrokes. After each band of colour dilute the mix with water, reducing the strength as you move down the paper. When dry, add a touch of burnt umber to the wash and paint in the distant hills and foreground water.

variegated wash

This type of wash is ideal for a sunrise or sunset, where you want a soft transition with at least three colours. Preparation is important, so have three colours ready mixed to complete the wash in one session – Winsor blue red shade, alizarin crimson and raw sienna. Apply a flat wash of the blue first. After about one third of the paper is covered, introduce the crimson for a similar distance, then bring the raw sienna right down the paper. When dry, mix the blue and alizarin and paint in the silhouetted landscape.

wet in wet

This type of approach is terrific for achieving liquid and softly blended passages throughout your pictures. It is especially good for skies, where no hard edges are wanted, or for a misty look.

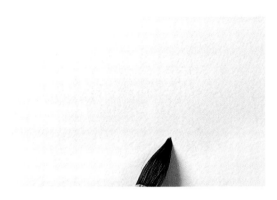

step 1

Prepare separate mixes of cobalt blue and light red. Paint a wash of blue all over with a No. 16 round brush.

step 2

While still wet, paint a strong mix of the red in the shape of a tree mass, then add blue on top of the wet wash to give shape and definition.

step 3

Using a strong mix of the colours, give the tree some support. Having worked quickly, the whole study should still be wet. Using your fingernail or the shaft of a rigger brush, pull upwards through the paint to suggest a selection of tree trunks. Leave to dry. Reinstate any branches that have softened into the background.

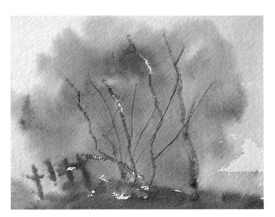

wet on dry

This is the method of painting one colour on top of another dry colour, without blending with the underlying wash.

step 1

Apply a wash of cobalt blue onto the sky. Add light red into this colour and wash the blue-grey mix across the bottom quarter.

step 2

Leave everything to dry. With the blue-grey mix used for the water in Step 1, roll the side of a loaded No. 16 round brush across the page diagonally, from the top right, giving the impression of soft clouds. Add more light red into the mix, and then define the hills and the boat.

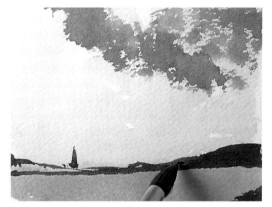

step 3

Strengthen the dark mix and paint in the foreground rocks and land. This technique is very useful for adding definition, such as a strong cloud formation onto a sky, or to add texture to a door, wall, tree trunk or rock formation, for example, without the risk of colours blending and edges blurring.

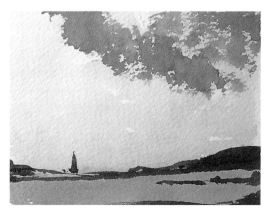

brush techniques

There are several ways to create different effects with brushes – use the point, side, belly or even the handle of round brushes to pull out colour, and flat brushes for lines such as windows or poles.

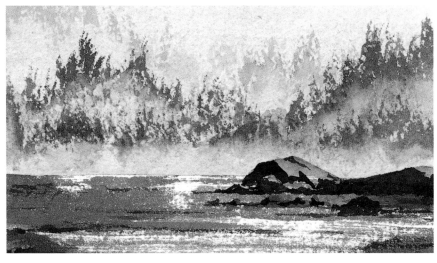

drybrush

This technique uses a dry brush with little paint to convey texture, especially when applied to dry paper. Add a little or no water to the paint, and apply with a rolling or dragging motion using the side of the brush for a loose effect. Drybrush can be used for many subjects – rough bark, texture on wood or walls, foliage on trees, shrubs, grasses and rusty metal. In this study, I started with a flat wash of cobalt blue. With the addition of a little burnt umber, I painted wet in wet on the distant conifers to soften them into the background. I allowed the paper to dry out a little, and painted in the tops of the mid-distance trees. With raw sienna and a little cobalt blue, the closest trees were put in by laying the side of a No. 6 round brush with the point upwards, in a stippling motion. I painted the water with the drybrush method, letting a No. 16 round brush skip across the paper leaving areas of white showing through for sunlight on the water.

splattering

This is a great way to suggest random texture. Use splattering to age rotting wood, brick, stonework and paint.

step 1

Paint a pale raw sienna sky and, while still wet, add French ultramarine down to the horizon. Paint the shore with raw sienna and allow to dry.

step 2

Place masking tape along the horizon line to protect the sky. Mix French ultramarine and burnt umber, dip in an old toothbrush and hold it with the bristles upwards. Drag a craft knife towards you across the toothbrush, so that the paint splatters across the paper. Repeat on the closest shore.

step 3

Remove the masking tape and paint the distant headland with a pale mix of the sky colours. Closer up, add some of the splatter colour to the nearer rocks. Paint in the water's edge with the sky colours.

mediums

Some exciting new mediums have recently been introduced by **Winsor & Newton Colart** to give watercolour artists further innovative and unique ways to expand their repertoire, through the choices of effects available.

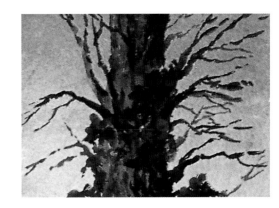

texture medium

Texture Medium contains fine particles and can be used to give the impression of depth and structure when added to your watercolour paint. In the example above left, I used this on a sandy beach, and in the example above right, I added texture to the bark on the old tree. You can also see an example of the use of this medium to give depth and texture to the old plasterwork on page 83. You can use Texture Medium to build up different layers of texture, for instance on a rock face. Texture Medium is resoluble but, like all watercolour washes, some colour will remain on the surface, ready for building up multiple layers on old wooden doors, rusty metal and anything that needs an aged look added to it.

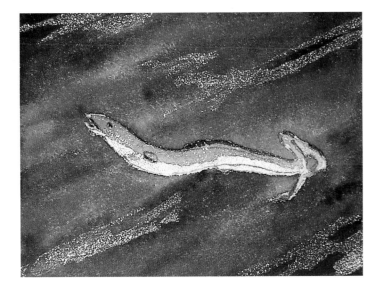

iridescent medium

Iridescent Medium gives a pearl-like, or glitter, effect to watercolours. This example shows an eel with silvery sides; I also used it to indicate sparkle in the water. You can add Iridescent Medium to your pictures afterwards or mix it with any colour that you are using. It is great for making personalized Christmas cards and adding that touch of sparkle to the snow. You could also use it to paint highlights on pearls or glistening jewels in a necklace.

granulation medium

Some watercolour paints granulate naturally to give an effect that adds interest to certain areas of a picture. Granulation Medium gives you the opportunity to introduce this grainy effect to colours whose character does not include this effect naturally. In this example I used Winsor red, which gives a smooth, grain-free wash, on the left-hand side; on the right-hand side, I added Granulation Medium to give me the option of a granulated effect.

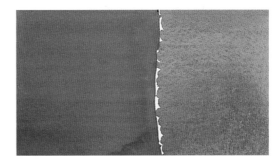

masking

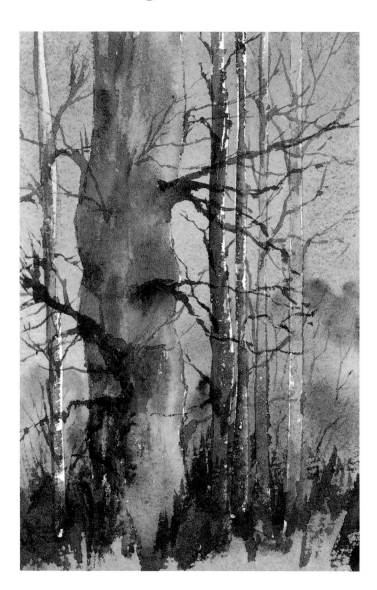

There are several methods of masking out or preserving the underlying paper or colour – masking tape, masking fluid and Permanent Masking Medium.

masking tape

Masking tape is very good for retaining straight edges, but you don't have to stop there! In the picture on the left, I cut strips of masking tape into varying widths to represent thin tree trunks. For the largest tree, I tore a length of 50mm (2in) wide masking tape in half, reversed the two pieces so that the straight outside edges were facing the middle, and stuck them down. This gave me an irregular outside edge that matched the other outside edge. I painted the background in French ultramarine, and added burnt sienna and burnt umber wet in wet to suggest distant trees. When dry, I removed the masking tape from all but the main tree and indicated small branches and twigs with a rigger brush. I then removed the tape from the main tree and painted a wash of raw sienna the full length of the trunk. I added French ultramarine and burnt umber to shape the tree while still wet. Darker branches of the same mix over-lapped the other trees to link the whole picture together, and I drybrushed the same dark colour into the undergrowth to anchor the trees to the ground.

masking fluid

Masking fluid is very useful for protecting highlights. Apply the fluid just before painting the picture, as it is easier to remove when fresh. Don't use soft watercolour paper, as the dried masking fluid pulls the soft surface.

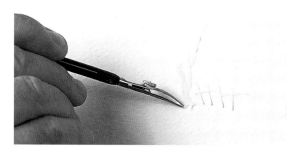

step 1

Use a mapping or ruling pen to apply very thin lines of masking fluid to an initial sketch – I drew a small tree with fine branches and suggested a fence.

step 2

Wash a strong mix of French ultramarine and Payne's grey around the tree. When dry, pull off the masking fluid, which is a rubberized solution, with you fingers. You can then give shape to the white protected areas with colours of your choice, paler than the dark wash behind.

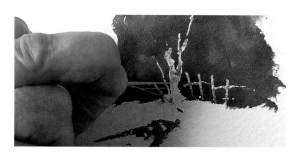

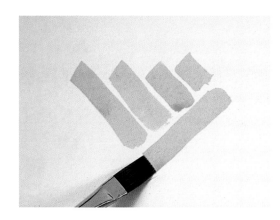

permanent masking medium

This is used to permanently mask specific areas. It can also be mixed with a colour and is ideal for isolating areas of fine detail. It is used in the Sunday painting on page 74.

step 1

Mix raw sienna with Permanent Masking Medium and apply short brushstrokes with a flat brush. Leave to dry.

step 2

Paint a wash of Winsor red to cover the raw sienna. As you can see, the area mixed with Permanent Masking Medium has resisted the red. The medium is very useful for pre-painting long, spiky grasses or any delicate work, as you are then able to paint a dark background and retain the highlights. As its name implies, Permanent Masking Medium cannot be removed.

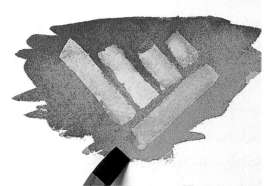

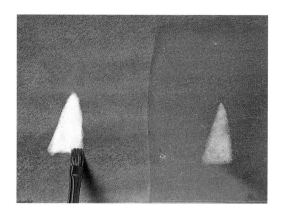

lifting preparation

Lifting Preparation is a colourless medium. When applied to the paper before you start, it allows you to decide later where to lift out even strong staining colours. You can also make corrections. It is used in the picture on page 36.

step 1

Paint the left-hand side of the paper with Lifting Preparation and leave the right-hand side untreated.

step 2

Apply a very dark wash over the whole sheet, and then leave this to dry completely.

step 3

Wet a small, stiff hoghair brush using a clean pot of water. Use the damp brush to paint the basic shape of a yacht sail, on both sides of the paper. The brush will lift out the paint colour. You can see clearly how much cleaner and crisper the sail appears on the side coated with Lifting Preparation.

composition

Once you are familiar with the basic rules of composition, your pictures will improve out of all recognition.

First, you need to decide the viewpoint and the main subject, or focal point. There are various techniques to help achieve balance and a sense of depth in your landscape painting, and to help lead the viewer's eye to where you want it to go!

As a general rule, the best place to put your main subject is where the thirds intersect: divide a piece of plain paper into a grid of thirds with very faint pencil lines. You should now have nine boxes. The best place to place the focal point is where the lines intersect, at four possible sites.

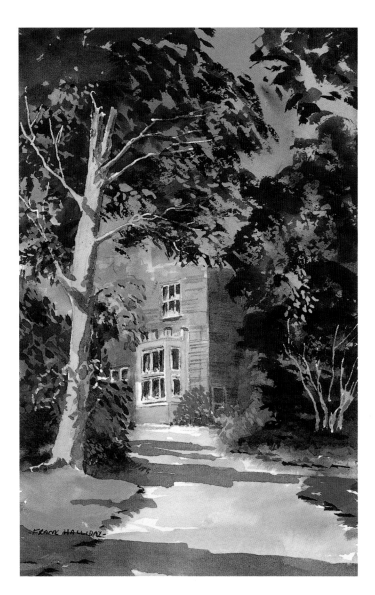

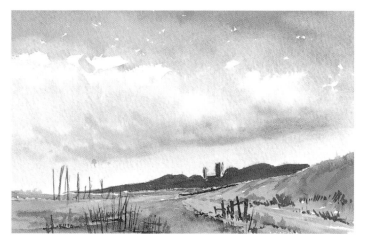

LATE GLOW

This little study was composed at the end of a day's painting, just as the sun was getting low. I placed the distant church approximately one third in from the right and one third up from the bottom. To emphasize this, the right-hand grass bank leads the eye into the picture, and the same applies to the path and the left-hand landscape. The foreground reeds and the section of broken fence echo the same theme. The actual content of the picture is minimal, but says all it needs to say.

ASHWELLTHORPE HALL, NORFOLK

The composition in this picture is focused on the large bay window. Here again, the main object has been placed approximately a third in from the left and a third up from the base. The composition is complemented by the sunlit tree trunk on the left, coupled with the path leading the viewer's eye into the picture. The dark shadows on the trees frame the main object, and the sun on the path and face of the building add to the picture.

choosing a viewpoint

You can paint a beautiful scene with expert skill, but if your viewpoint is poor, the composition will not hold together and the result will be unsatisfactory. Once you have found your perfect scene, take the time to walk around, looking at it from different angles – crouch down, even turn around, there may be a terrific picture just behind you!

assessing the view

When you finally decide on a particular view, ask yourself what is the main feature? Is it placed on one of the thirds? Are the surrounding objects necessary, and do they complement the composition? On this page are two examples of a poor choice of view – yet by just walking around a little, they become less static and square-on, creating a three-dimensional composition rather than a virtually flat, two-dimensional view.

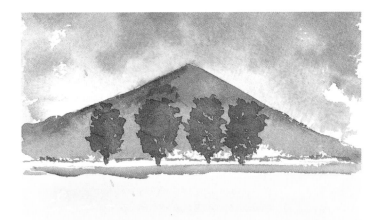

ABOVE – POOR COMPOSITION

The four trees, which are all the same size, are placed centrally, like the mountain, and everything appears very symmetrical.

BELOW – IMPROVED COMPOSITION

Viewed from the right, perspective takes over and the trees appear to reduce in size. The lane takes us into the picture and we can now see the detail on the mountain, giving the opportunity for more sculpting.

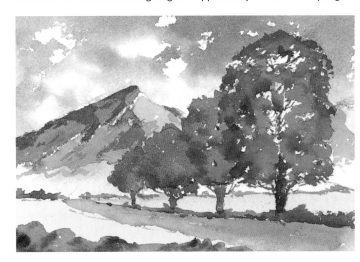

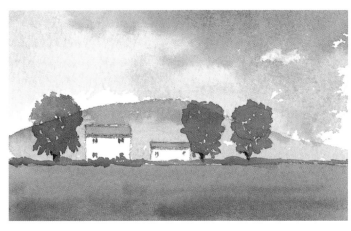

ABOVE – POOR COMPOSITION

Here, the trees compete equally for attention and the two buildings are single, flat-faced items. The road goes straight across the picture plane.

BELOW – IMPROVED COMPOSITION

Moving to the left, the large building takes the focal point and slightly overlaps the smaller building. The trees and the road lead into the distance, and the heavy cloud top right balances the colour bottom left.

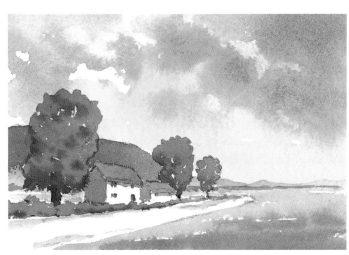

23

linear perspective

Many books have been written on this subject alone – I cannot cover every aspect, but I do feel it is very important for beginners to study the basics that lead to good pictures.

Linear perspective gives the impression of three-dimensional space and recession. It uses the simple rule, known as one-point perspective, that parallel lines appear to converge at a point on the horizon (the vanishing point), and can also be illustrated by making objects appear smaller as they recede into the distance.

parallel lines

Lines appear in many landscapes – furrows in fields, roads, fences, a shoreline or cliff edge. Look carefully at the angle of the lines as they move into the distance towards their vanishing point. Buildings also respond to linear perspective: viewed square on, all you see is a rectangle; viewed from the corner, the parallel sides will start to diminish towards a vanishing point (see right). The most important line is your eye level – an imaginary line across your picture, level with your eyes. The lines of anything above eye level come down to a vanishing point on this line; below eye level the lines come up.

creating distance

To help add a sense of distance you can make objects appear smaller in the distance. Overlapping receding objects also adds to the sense of perspective.

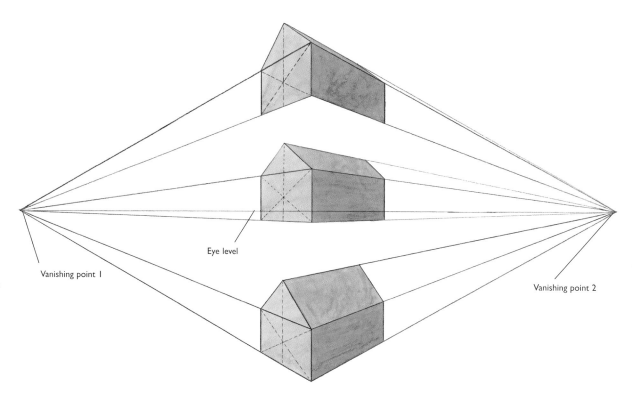

Vanishing point 1

Eye level

Vanishing point 2

TWO-POINT PERSPECTIVE

Each side of the building has a separate vanishing point, known as two-point perspective. In the middle example the eye level goes through the middle; the rooflines of the building also go down to the same vanishing point. On the building below, they go up to the same point, and on the one above, the lines go down. To find the correct place for the apex of the roof, lightly put a cross, as indicated, on the building ends to find the centre lines.

RUNTON BEACH

Linear perspective does not just apply to buildings – in this picture one-point perspective comes into play and is very important for conveying depth and recession through a convergence of lines to a vanishing point on the far horizon. The cliffs follow a line into the distance and also reduce in tonal value as they move away. The waves at the edge of the beach and the wet sand all follow the same rules towards the same vanishing point. The centre of interest is the beach and the people enjoying a day out.

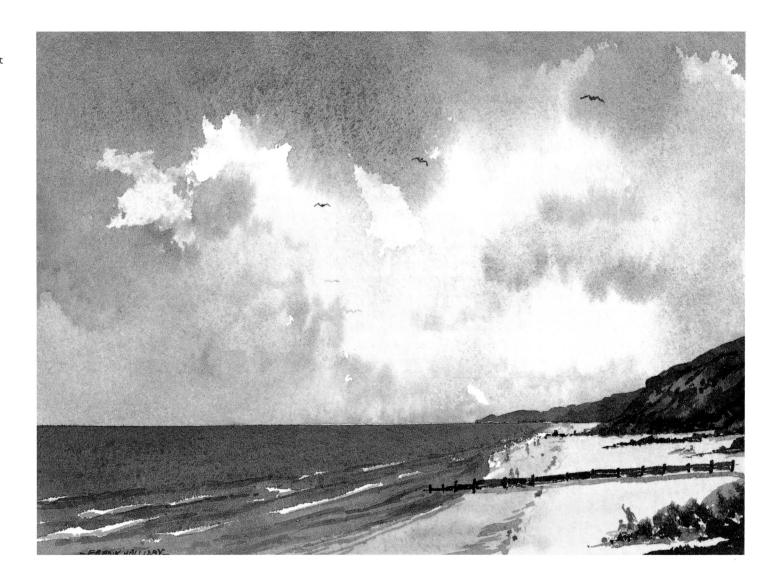

aerial perspective

This technique is ideally suited to landscapes – it exploits the natural contrasts of tone and texture to convey depth and distance. The best way to understand aerial perspective is to paint an example. You can achieve the effect of receding space by using cooler, paler values in the distance, and warmer, darker values closer up.

AVENUE OF TREES

In this quick study, I sketched an avenue of identical trees, but chose a viewpoint looking at them receding into the distance, following the rules of linear perspective. To paint all the trees the same colour and tone would convey to the viewer that these trees were the same distance away, and that some were physically smaller. This is where aerial perspective comes into play: the far distant trees are pale in tone and have taken on a blue look. They are also less clearly defined than the foreground trees – the further away an object is from you, the less detail is visible.

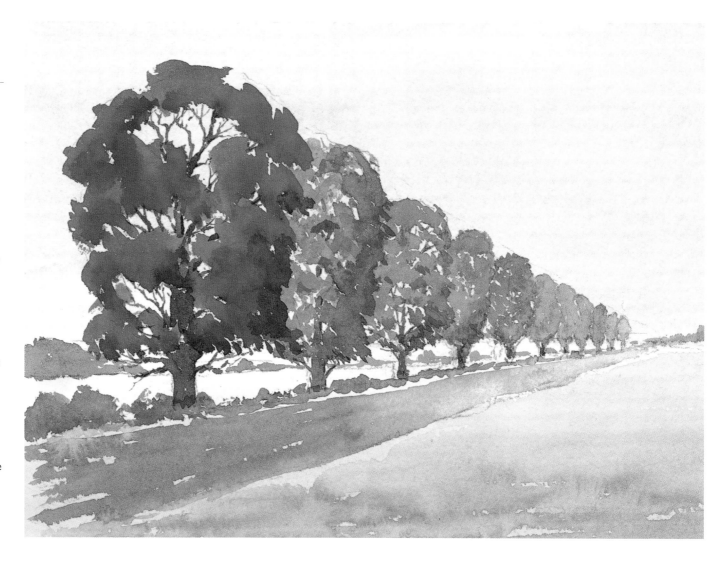

THE LONELY BEACH

Before we move off the subject of perspective, here is a further example, where both linear and aerial perspective are employed to achieve the three-dimensional look we strive for on a flat piece of paper. To make things a little more complicated, I have introduced an additional vanishing point. The cliffs were sketched in using a vanishing point just off the left of the picture plane, and they appear to get smaller towards this point. The surf, reflecting the evening sky, has its own vanishing point at the foot of the right-hand cliff, and the lines converge as it moves towards this point. Aerial perspective is demonstrated by the recession in tonal value of the cliffs as they move to the left, and the same applies to the sea and sand where the stronger tones are closest to you.

I hope these few pages relating to basic perspective have helped you to understand this complex subject – if you have mastered these points, you are on your way!

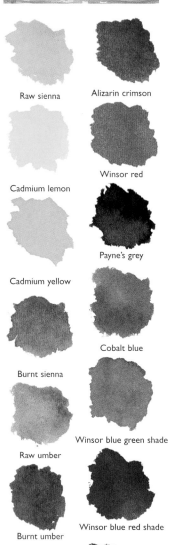
Raw sienna

Alizarin crimson

Cadmium lemon

Winsor red

Cadmium yellow

Payne's grey

Cobalt blue

Burnt sienna

Winsor blue green shade

Raw umber

Winsor blue red shade

Burnt umber

Light red

French ultramarine

colour

With colour you must develop your own individual palette – be advised by experienced artists and take on board the tones and hues that suit your style of painting and subject matter. On the left is my palette of 14 colours; I could probably halve this if necessary, but with these paints I can mix further colours, with greater speed.

To help you create natural colours quickly, I have suggested below a few colour mixes for the most popular landscape subjects. Try your own combinations and ask yourself, 'What have I seen that is this colour?', then make a note of it for future reference.

Fresh spring greens, grasses and leaves: *Winsor blue red shade with cadmium lemon* or *Winsor blue red shade with cadmium yellow.*
Autumn greens, when things are getting to the end of the growing season: *Winsor blue red shade with raw sienna.*
Winter scrub and dead grasses in muted tones: different proportions of *raw sienna, burnt sienna and burnt umber.*
Rich greens for deep shade and evergreens: *Cadmium lemon with Payne's grey.*
Introducing *burnt umber* to the combinations above will provide an endless variation of

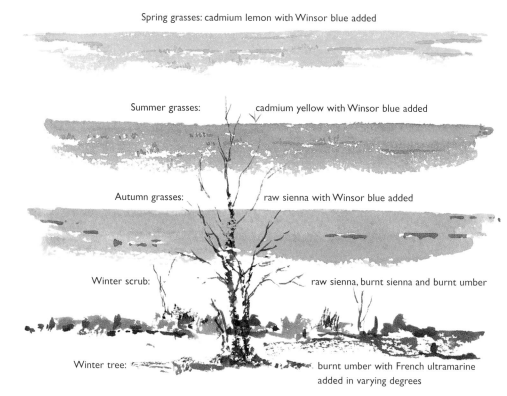

Spring grasses: cadmium lemon with Winsor blue added

Summer grasses: cadmium yellow with Winsor blue added

Autumn grasses: raw sienna with Winsor blue added

Winter scrub: raw sienna, burnt sienna and burnt umber

Winter tree: burnt umber with French ultramarine added in varying degrees

LANDSCAPE COLOURS

This sketch shows just a small sample of the different colours that can be found in the landscape throughout the year, and gives suggestions for colour mixes.

darker shades for areas in shadow.
Grainy sky: *French ultramarine.* Add a little *alizarin crimson* for a more delicate grey. Add a little *burnt umber* for a range of greys.
Distant hills, trees and buildings: *Cobalt blue and light red* or *French ultramarine and alizarin crimson.*
Pantile roofing: *Light red* or *burnt*

sienna with French ultramarine.
Branches and tree trunks: *French ultramarine and raw sienna.* Vary mixes for sunlit areas.
Brickwork: *Burnt sienna, light red and burnt umber.*
Stonework: *Raw umber and French ultramarine.*
White sails: thin wash of *raw sienna.*
Tan sails: *Burnt sienna and burnt umber* or *light red and burnt umber.*

The best way to show colour in action is to paint. On this page I have taken virtually the same scene and changed the mood and temperature by my choice of colours. When you compare the two pictures, you can see how much difference the choice of colours makes. Strong examples have been used to demonstrate the point, but usually the differences are much more subtle.

cool colours

In this picture I purposely left out any colours that are from the warm side of the spectrum. The sky was French ultramarine washed all over the picture area. While still wet, I added Payne's grey wet in wet at the top of the sky to the mix to give a cool grey cloud colour. When everything was dry, I used the same, but diluted, wash to pick out the skyline of buildings. I let it dry and then put in the sides of the buildings against the light with a stronger mix of the same colour, then indicated reflections into the foreground water and painted the disturbance on the nearest water with a darker tone.

warm colours

Here you can see that the mood is completely changed by my choice of colours. In this study, only warm colours were employed, steering away from anything cool. I used the same techniques to complete the picture, but this time I used raw sienna all over and dropped Winsor red into the wet sky. After drying, I painted in the buildings, indicating the shadow sides.

GOLDEN RULES

1 always use clean water and brushes
2 always use a clean palette
3 try not to mix more than two colours together
4 when mixing colours, always make more than you think you will need – it is very difficult to get an identical mix again
5 when painting wet in wet, have all the colours you intend using ready-mixed

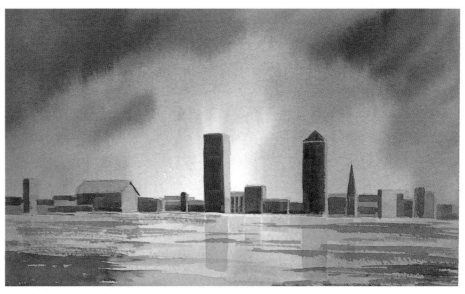

COOL COLOURS

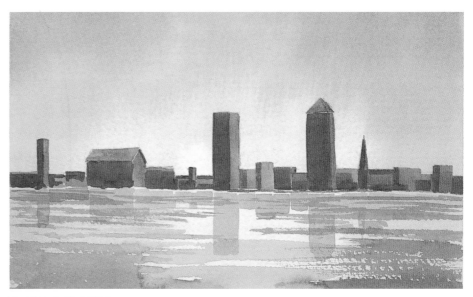

WARM COLOURS

understanding colour

I could write pages on the effects of the colour wheel, but I know from experience that people want to paint pictures and are more likely to spend time on the exercises, being tempted to skip the pages on mixing colours. Here is a challenge to help you understand your colours.

COTTAGE IN THE COUNTRY

Pick a colour from your palette that you use most frequently – I chose burnt umber – and with just this one colour try to paint this cottage in the countryside. You can immediately see that by varying the strengths of paint and water you can produce many different tonal values. You will come across this kind of lighting on your travels, and the more limited you make your palette the more successful your picture will be. The main object of this exercise is that, on completion, you will know much, much more about your chosen colour and how versatile you have found it to be.

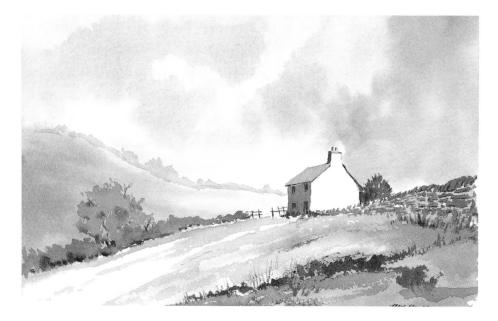

FALLEN SNOW

Are you now ready to try the second challenge? I added a second colour, French ultramarine, to the burnt umber; so this time we are painting with the colours and tones that you can make with two colours – this is really spoiling you! When you start combining these colours, you have at your disposal some beautiful cool and warm greys. The more burnt umber you add, the warmer the tone becomes, and it is cooler as the blue is increased. Use your skills covered in the wet-in-wet section for the sky, and vary the colours to paint the trees and bushes behind the building – make them bluer as they go away from you, using the knowledge gained of aerial perspective. Paint the foreground in stronger tones and use the subdued blue to indicate shadows on the snow. This exercise will show you how you can achieve a detailed, finished painting with a very limited palette.

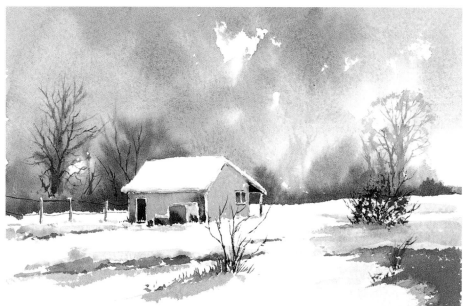

FARMHOUSE IN HIGH SUMMER

This is one of those lovely days I dream about in cold wet winters. The corn is high, and I would just love to walk down the lane, past the farm, listening to the birds and feeling the warm sun on my back.

I used mainly just three colours to capture the light and warmth. The sky wash was a mix of raw sienna, French ultramarine and a touch of burnt umber. The corn fields were the raw sienna sunshine colour – I streaked burnt umber into the wet wash to give the impression of a breeze moving the corn like waves. I also used just a touch of cadmium yellow for the foreground trees.

I placed the trees to frame the white farm for maximum light against dark. The white farm is the white of the paper – much better than trying to paint a white. Shadows on the farm and on the path from a dead tree off picture to the right, finish off the composition.

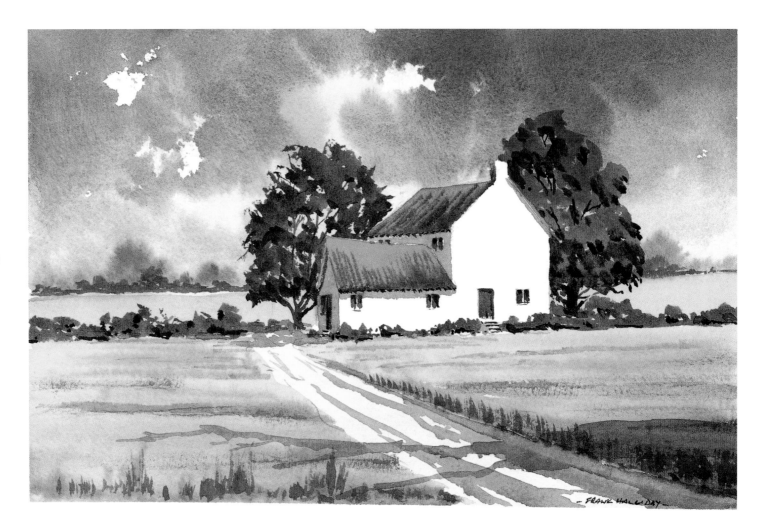

FRANK HALLIDAY

project 1 · skies and clouds

On the many occasions that I have been asked to judge art competitions, I have seen potentially very good pictures, spoiled by the lack of attention to skies and their effect on the mood of the painting.

The first thing to consider is the direction of light and the mood you are trying to convey. Do you want to create a calm effect or a dramatic effect? The colours you choose before starting the picture make all the difference. If you want a cool painting choose blues and greens, if you are trying to create an ambience of warmth, choose reds, yellows and earth colours. Skies are all different, but fall into certain categories. Let's paint a few.

clear sky

ACROSS THE MARSH

This was a lovely day and the light was perfect. Starting at the top with a No. 16 round brush, I washed in Winsor blue red shade, reducing the strength of colour by adding more clean water as I moved down towards the horizon. As I reached halfway, I introduced a little alizarin crimson to the same wash and painted down to the horizon, then painted the same colours into the water. The greens were made of different mixes of raw sienna and Winsor blue red shade, and I increased the strengths towards the front of the painting.

cumulus clouds

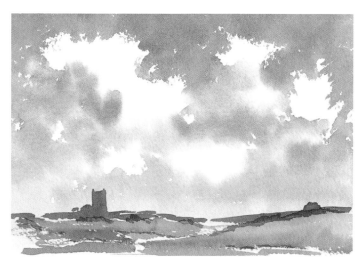

TOWARDS THE CHURCH

I think my favourite sky is lively cumulus clouds billowing above an open landscape. The light in this little picture is coming from the top right. Using a No. 16 round brush, I wetted the central area of the sky with clean water, quickly painted in the raw sienna, and then painted the blue above and around the sienna, encroaching into the wet colour in places. I introduced alizarin into the blue for the bottom of the sky. While still wet, I painted up into the raw sienna to shape the underside of the clouds. Using mixes of the sky colours, I added a simple landscape.

exercise 1: cirrus clouds

step 1

Mix a wash of French ultramarine and paint a graduated wash across the whole of your sheet of paper with a No. 16 round brush.

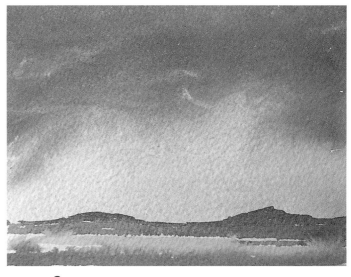

step 2

Working quickly to ensure that the sky area is still very wet, take a piece of tissue and drag it across the sky with a twisting movement – the tissue absorbs the wet blue wash in a random pattern just like the randomness of a cirrus cloud formation. Leave to dry.

step 3

When the sky is completely dry, introduce a simple landscape using the blue wash with a touch of burnt umber to create distant hills; add a little cadmium yellow for the foreground grass.

exercise 2: rainclouds

step 1

Have your washes ready mixed before you start. Make a strong mix of Payne's grey, and then a raw sienna wash. Paint a flat wash of sienna all over the picture area with a No. 16 round brush.

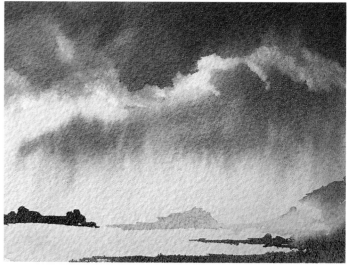

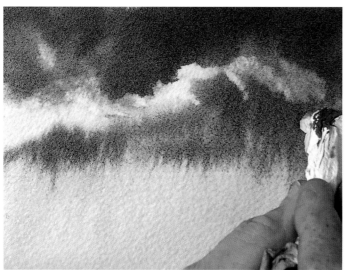

step 2

Stroke the Payne's grey into the top of the picture, just as the shine goes off the raw sienna wash. Angle your board at about 15 degrees, allowing this second wash to seep downwards and create the effect of rain falling out of a heavy sky. With a tissue, lift out areas of the dark wash in a cloud formation to reveal the underlying light of the previous wash. Leave to dry.

step 3

Using varying dilutions of the Payne's grey wash, put in the pale, distant land mass and the darker shoreline. Finally, add the shoreline closest to you, carefully avoiding the lightest part of the picture, the sunlit sea; use a No. 6 round brush for this more detailed work. Use this kind of sky when you want to add punch to your pictures. Practise it a few times on the back of unwanted pictures, and see how quickly you become an expert.

exercise 3: sunset

step 1

For a successful sunset, avoid garish, bright colours. Mix three separate washes of raw sienna, alizarin crimson and French ultramarine with burnt umber. Add Blending Medium to each wash. Turn the board upside down and apply the first wash of raw sienna across a third of the picture area.

step 2

While the raw sienna wash is still wet, add alizarin crimson, just slightly overlapping the previous colour. Continue to add the wash over approximately a third of the paper.

step 3

Next, introduce the French ultramarine and burnt umber mix for the final third of the picture, again overlapping the previous wash.

step 4

Turn the board the correct way up while everything is still wet. With the strong blue mix, paint in slightly angled dark bands of colour onto the alizarin portion of the sky and across the raw sienna part. Leave to dry. The Blending Medium allows more time to work on the wash.

step 5

When you paint an evening sky, most of the objects in front of you appear in silhouette, giving the effect of more light to the backdrop of sky behind them. With a No. 6 round and the strong mix of blue and burnt umber, paint the outline of the landscape in a single tone. Choose your view during the day, then paint your sunset in the comfort of your home.

dramatic skies

SUNNY DAY AND CORNFIELDS

In this type of sky you get wonderful effects from the shafts of light coming down through a cloud-covered scene.

I coated the sky area and distant land with Lifting Preparation, to give me the flexibility of choosing where to place the shafts of light. I painted a cumulus sky using French ultramarine, raw sienna and alizarin crimson, then painted the landscape with raw sienna. When dry, I painted in the distant tree line with the cloud colour. Using the sky colour across your painting gives it a sense of unity.

I used aerial perspective for the hedgerows in the distance, painting a pale wash of raw sienna and French ultramarine and increasing the strength coming forwards until the closest hedges and main tree changed to cadmium yellow and Winsor blue red shade.

I lifted out the shafts of light by placing random strips of masking tape angled down the painting, from the sunlit area to the cornfield. With clean water and a clean stiff hoghair brush, I rubbed down the areas not covered with tape and mopped the excess water with a tissue. When dry, I removed the masking tape.

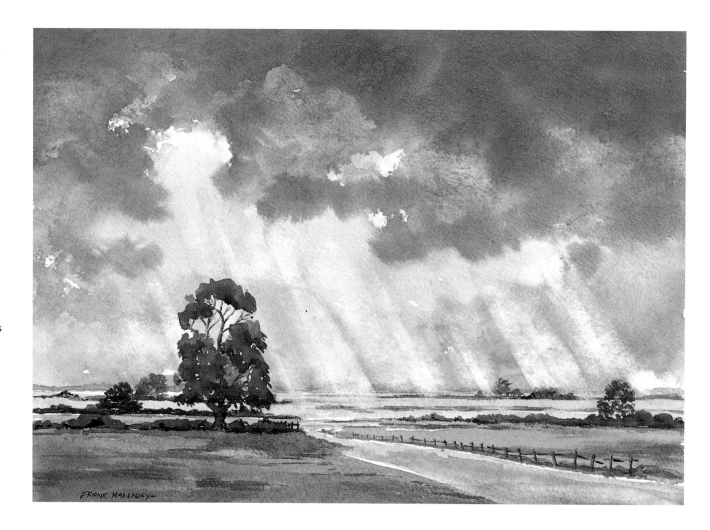

MORSTON QUAY, NORFOLK

I wanted to include a picture from Norfolk,
where I have lived for the past 18 years. The
light is so perfect and never fails to thrill me
with ever-changing skies, the vast openness
of the mud flats and boats at low tide. The
colours for this sky were premixed, ready to
go for it without pause – raw sienna, French
ultramarine and burnt umber.

I partially wetted the sky area with clean
water, dropped in the raw sienna, painted
around and in amongst this with the French
ultramarine, with a touch of alizarin crimson
at the base of the sky, then tucked the
alizarin under the raw sienna to create
clouds. The large, ominous cloud (French
ultramarine and burnt umber) moving from
the right, clears the sun, which shines
brightly on the boat, casting strong shadows
to the left. I painted the marsh grasses with
a mixture of raw sienna and French
ultramarine, increasing the quantity of raw
sienna as I brought the marsh forwards.
The water in the creek is a reflection of
the sky colours.

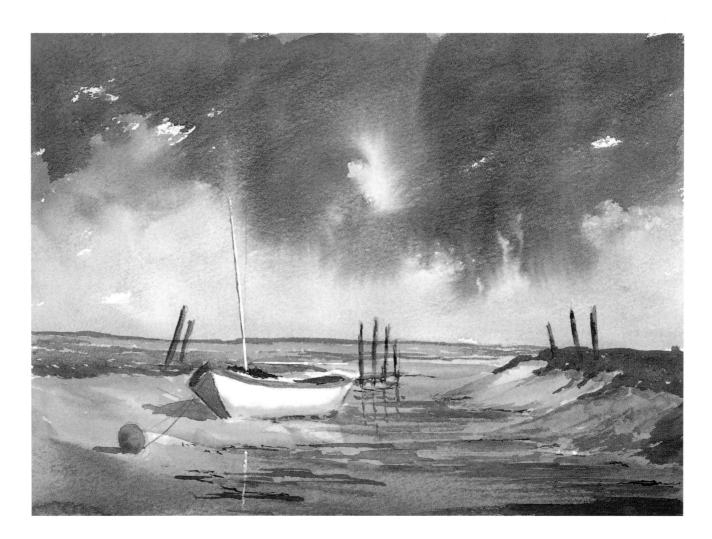

towards the village

Now it is time to put some of the techniques from the Saturday sky exercises into a big **Sunday** painting. As this is essentially a sky picture, I purposely chose a low horizon to give full emphasis to a big sky. As we go through the steps, you will see that I have brought into play a dramatic cumulus sky with strong lighting from the left of the picture. A sense of depth is achieved by using tonal recession, combined with the effects of linear perspective in the furrows of the foreground field, taking the viewer towards the distant church. The large, full summer tree on the left is balanced by the heavy storm cloud full of rain, coming from the right-hand corner to spoil a lovely day.

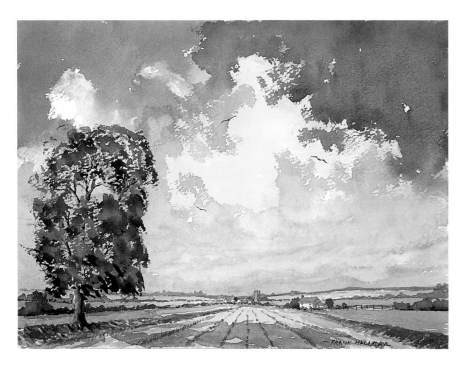

YOU WILL NEED

Colours

- raw sienna
- French ultramarine
- burnt umber
- alizarin crimson
- burnt sienna
- Winsor blue red shade
- cadmium yellow
- Payne's grey
- light red
- cobalt blue

Brushes

- No. 16 round (for washes and large areas)
- No. 6 round (for general detailed work)
- No. I rigger (for fine detail)

Paper and other equipment

- Winsor & Newton Lana Aquarelle Rough 600gsm (300lb) or Winsor & Newton Lana Aquarelle Rough 300gsm (140lb), which will need stretching
- soft putty eraser
- 4B pencil

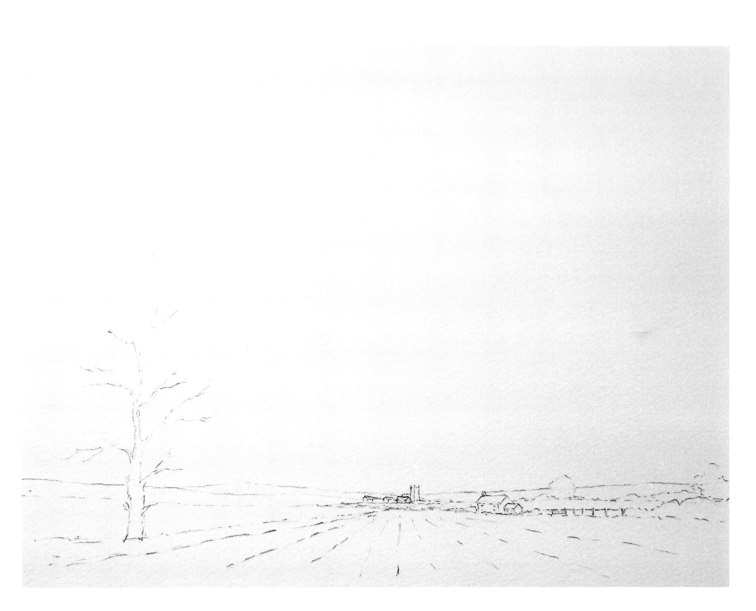

INITIAL DRAWING

If you find yourself struggling with making a sketch, place tracing paper over this one and follow the lines with a soft pencil. Blacken the back of your paper with a soft pencil, tape it to your watercolour paper and go over the drawing carefully to transfer the lines onto the paper. If you wish to work larger, enlarge this sketch on a photo-copier and then do as above.

Why not save your traced sketches and use them to make paintings of the same scene in different seasons?

step 1

Prepare washes of raw sienna, French ultramarine, and French ultramarine with burnt umber. Wet the central area of the sky with clean water, immediately put in the raw sienna wash with a No. 16 round brush, and carry this down across the foreground field.

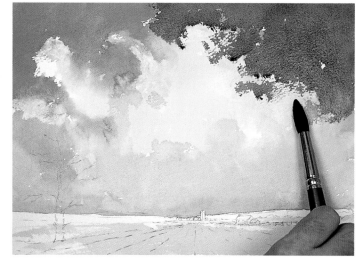

step 2

While still wet, introduce the French ultramarine from the top, running into the raw sienna and working round and down towards the horizon. Angle the board upright to increase the downward flow. To prevent the French ultramarine running fully into the raw sienna, take a tissue and lift out cloud shapes from the blue closest to the sunny central area. You will be amazed at how easily you can form effective clouds by this method.

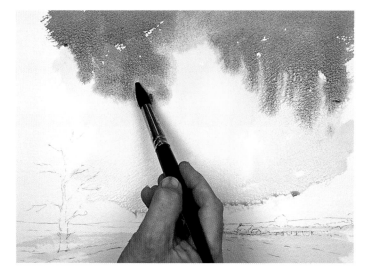

step 3

Because you are working so quickly, everything should still be wet. You can now introduce the alizarin crimson into the existing wash of French ultramarine blue using the large brush. Continue towards the horizon and at the same time push this mixture up into the underside of the wet raw sienna to form cloud shapes.

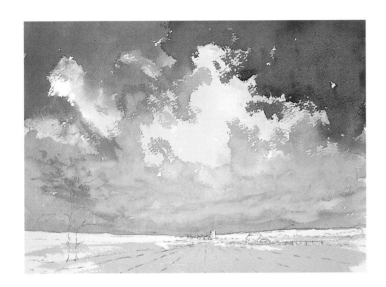

step 4

Using the same mix, add smaller and more distant clouds – this area is further from you and the clouds should diminish in size, obeying the rules of perspective as the landscape recedes. Let the sky dry and prepare a strong mix of French ultramarine and burnt umber for a really dark, stormy cloud colour. With a wet-on-dry technique, paint in the large dark cloud at the top right, using a No. 16 round brush loaded with colour, then place the side (or belly) of the brush onto the paper and roll the brush down and across. This will give you a much more realistic look to a cloud formation than trying to paint it.

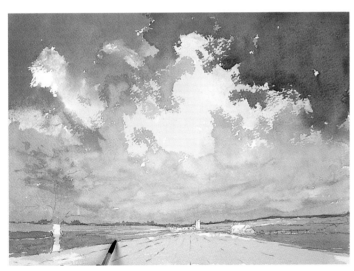

step 5

For the background landscape, mix cobalt blue and light red to create a blue-grey and paint a narrow strip across the base of the sky, varying the height very slightly as though an occasional tree protrudes along the horizon. Mix a blue-green from raw sienna and French ultramarine, for the next band of landscape across your picture, then, increasing the raw sienna content of the mix, paint in the fields at each side of the church, making the mix paler into the distance. Use a warm mix of cadmium yellow and French ultramarine for the closest fields.

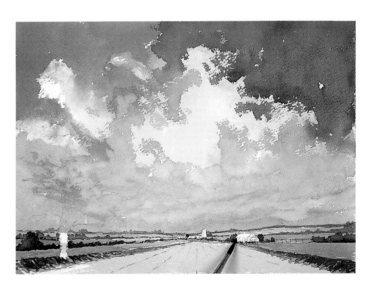

step 6

When completely dry, use the green mixes from Step 5 for the hedgerows; working from the back to the front and making the mixes stronger as you come forwards. Paint the ragged hedge of the field with the strongest greens closest, lightening it towards the focal point. A dark mix of this colour, placed by the white cottage, gives maximum contrast.

step 7

Using raw sienna mixed with burnt sienna, paint in the pantile roofs. Paint the church in one tone of raw sienna, and when dry, put an additional coat on the right-hand side because the sun is from the left, then paint the shaded sides of the houses with a mix of the cloud colour. Paint in the windows and the shadow cast by the overhanging roofs with the same mix. Add the small fence using the roof colour with a touch of the shadow colour.

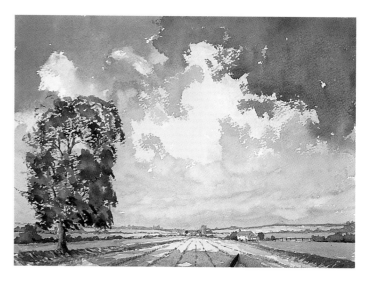

step 8

The easiest way to paint the impressive summer tree on the left is to put in the greenery before the trunk. Sweep in a mix of cadmium yellow and a little Winsor blue red shade with the side of a No. 16 round brush in a drybrush technique, leaving gaps for the branches and for the birds to fly through.

While still wet, paint in a darker mix of the same colours away from the sunlight, and to get the really juicy shadows add some Payne's grey. Use raw sienna for the trunk, and whilst

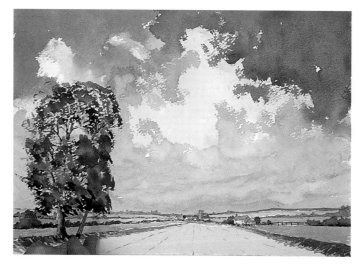

still wet, put in some of the cloud colour on the shadow side – this will creep around the tree and make the transition from light to dark more realistic. Use a No. 3 rigger brush to paint in the tracery of finer branches above the thick trunk.

step 9

In the final stages, a good habit to get into is to check the picture and ask yourself if you have missed anything, such as an obvious shadow, a distant roof not painted or a missing branch on the main tree – you will be surprised how often you find things! Using a weak mix of burnt umber, brush in the furrows on the foreground field with a No. 6 round brush, remembering to weaken the mix as you go into the distance. Use the cloud cover mix to paint in the large shadow cast by the main tree across the foreground field.

FINISHED PAINTING
250 x 350mm (10 x 13¾in)
On the finished painting I added three birds soaring on the thermals, just checking out what the farmer is doing and what food is about. This would be a regular feature of a scene like this, and also gives a little movement.

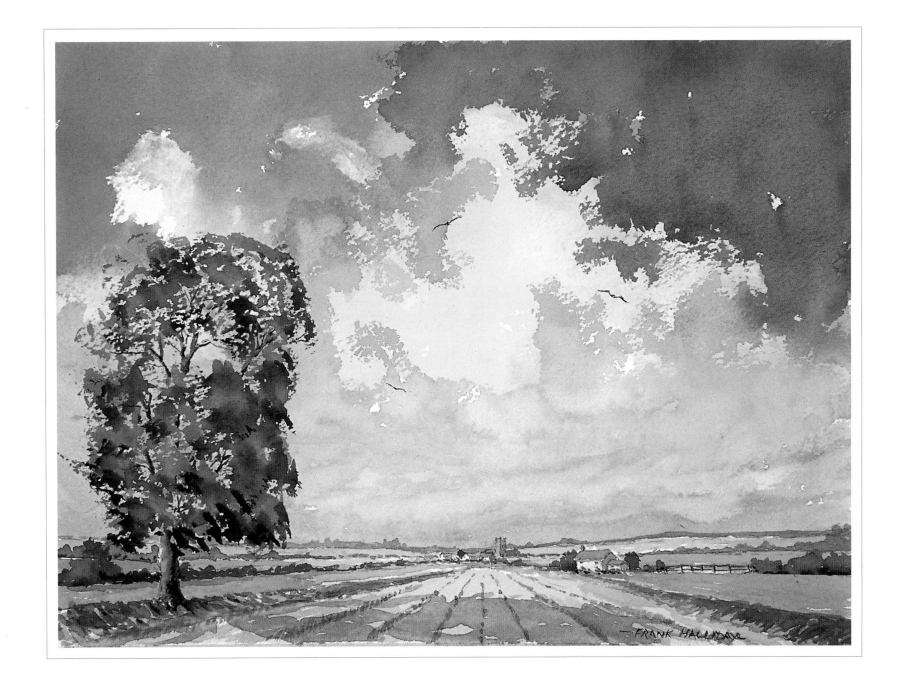

project 2 · water

sunlight on water

Now we have studied skies you should be raring to move on to the next challenge. I am often asked on my courses such questions as 'How do I stop water from looking as though it is going uphill?'. So, let's take the myth out of the problems with painting water. The Saturday exercises cover sunlit sparkle on water, reflections in water, just moving or falling water, a rough sea and turbulent water, so when you come to tackle the Sunday painting, you should have plenty of knowledge to start it with confidence.

THE GRAND CANAL, VENICE

I sketched out the shapes of the buildings along the waterline and painted on masking fluid to retain the whiteness of the paper for the sunlit area. I then painted the sky wet in wet with raw sienna and cobalt blue, and brought these colours down into the water area and let it all dry. With the blue of the sky, I painted in the distant buildings along the Grand Canal. I painted the buildings nearest to me in stronger tones, just to show a little bit of detail; the foreground canal is the darkest tone. I removed the masking fluid when everything was dry, and indicated one or two marks along the canal where the wave shapes and indentations on the water were seen against the light.

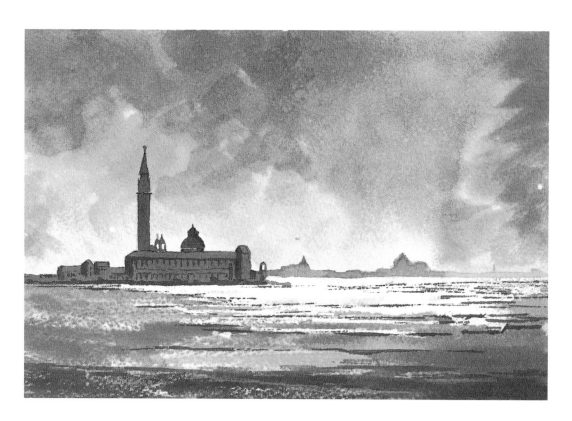

exercise 1: reflections in water

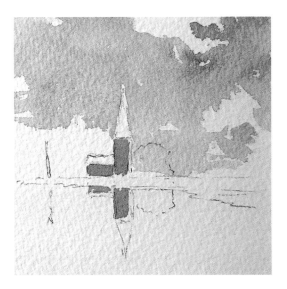

step 1

Apply a wash of French ultramarine to the sky with a No. 16 brush, leaving areas of white paper for clouds, then add some burnt umber into the French ultramarine to give some grey areas. Paint the church body in light red. To indicate the reflections in the water, imagine that the reflection comes from the base of the building and is equal to the height of the tower and spire. If you have an area of land below the reflected object, this must be included in the measurement. Add colour to the church reflection.

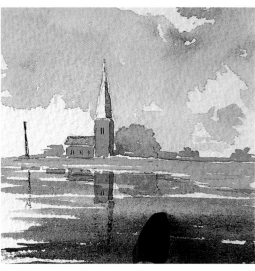

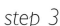

step 2

Use a No. 6 brush to paint the post on the left-hand side in burnt umber and to indicate the darks on the church spire. Paint the surrounding trees with a mix of French ultramarine and raw sienna, then add a little more raw sienna and wash in the river bank before reflecting these new items in the water.

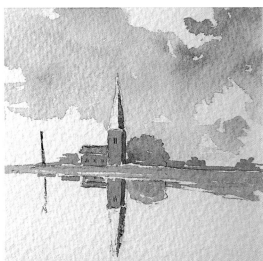

step 3

Transfer the sky colours into the lake and over the top of the reflections of the church and post. The light is coming from the left and creating a shadow area on the right-hand side of the spire and the church. This should also be indicated in the reflection. Strengthen the colour of the lake as it comes towards you, to provide tonal recession.

A good point to remember when painting reflections is that anything dark reflected into water appears lighter, and anything light appears darker – in other words, the tonal difference is closer together. One final point to bear in mind is that anything that is further back from the water's edge will not reflect in the water.

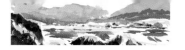

moving water

MELTING SNOW

I painted this as a demonstration for a group with a 50mm (2in) flat brush, working with a limited palette and a time limit of 10 minutes. I quickly dropped in the sky wash using French ultramarine, carefully avoiding the mountains, then used raw sienna to indicate the distant shoreline, the highlights of the foreground rocks and just as a suggestion on the sides of the mountains against the light.

Next, I mixed French ultramarine and burnt umber to create a darker blue colour for the shadow side of the mountains, quickly indicating these with the side of the brush. With a slightly weaker mix of the same tones, I put in the base of the mountains closer to us, then used burnt umber to paint the foreground rocks, those at the side of the water and one or two sticking out of the moving water as it comes over the edge of the waterfall.

I indicated the blue of the sky in the flat portion of the water, as the melting snow comes off the mountain and down towards the fast-flowing river, then made a suggestion of distant conifers with French ultramarine and raw sienna. Using the same shadow tones on the mountain, I brushed the direction of movement of the water as it came over the edge of the rocks in the foreground.

This is a very good exercise to try yourself – use the largest brush you own, do a few pencil lines, set the clock and give yourself 10 minutes to complete the painting. You will be amazed at how loose and fresh your picture can be.

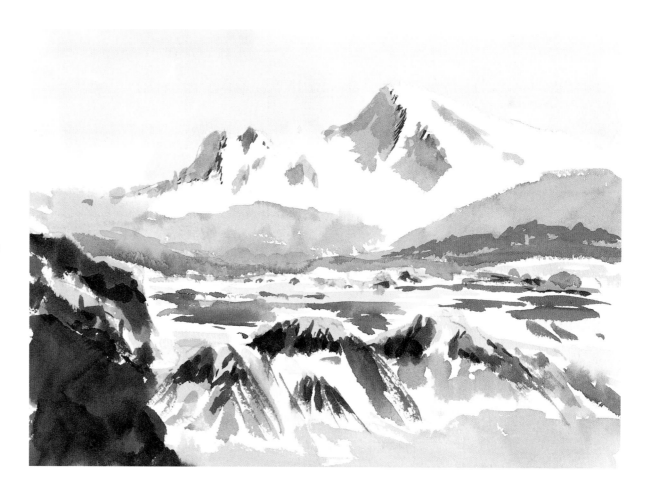

exercise 2: waterfall

step 1

Paint the sky and the sides of the hills with raw sienna using a No. 16 round brush. Then add a touch of French ultramarine to indicate the bush on the right-hand side with a No. 6 round brush, then apply different strengths of burnt umber in the damp sides of the cliff. Make downward movements in the water itself, using French ultramarine and the same brush, to show the direction of flow.

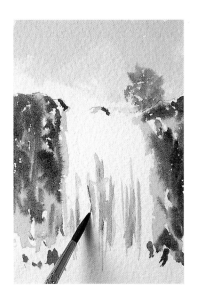

step 2

Mix French ultramarine and a touch of burnt umber, then indicate more of the direction of flow of the water with loose brushstrokes. Darken the bottom area. While all this is still wet, use a sponge to take out the foam at the base of the waterfall where everything is bubbling and foaming.

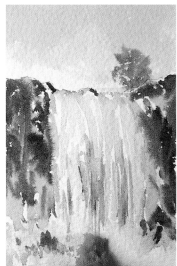

step 3

To give an element of scale to the waterfall, use a No. 3 rigger to include a tiny figure on the top left, standing on the rocks and looking down over the waterfall. With a No. 6 round brush, use some dark burnt umber and French ultramarine to give more definition to the rocks on the left and the right, and indicate one or two darks in the greys along the base of the waterline.

When you are painting anything where you want to indicate scale, painting an object of known size alongside it immediately indicates a clear relationship, and the viewer can thus have a reference point to make a judgement on the size of the object.

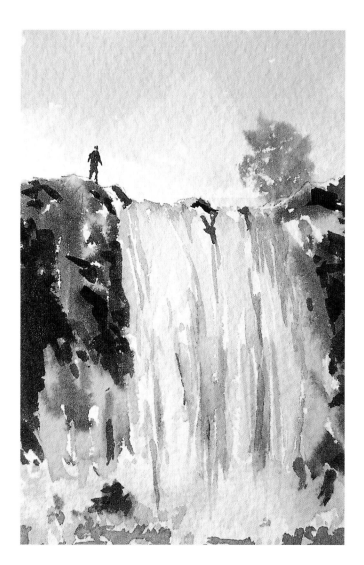

exercise 3: rough sea

step 1

Sketch out the background cliffs and the main rock. Using a toothbrush dipped into masking fluid, scrape a craft knife along the toothbrush to splatter the background rocks to indicate foam and spray. Use masking fluid on the lighter rocks where you want to retain a highlight.

step 2

Paint the highlighted rock, with the sun shining on it from the left, in raw sienna with a No. 16 round brush. With French ultramarine and burnt umber, paint the shadow area of the highlighted rock; add Payne's grey to make this colour really dark and paint the background large cliff down towards the highlighted rock. At the base, use a tissue and lift out the wet colour to give the effect of spray in the shadow against the main rock.

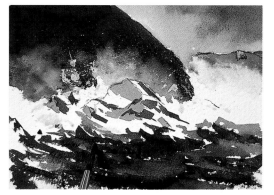

step 3

Dilute the foreground rock colour and paint in the distant cliff. Then tissue out the base of this colour to indicate foam from the sea. Paint the sky with raw sienna.

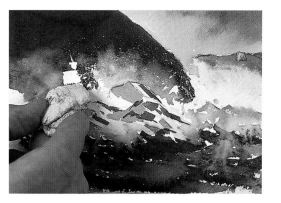

step 4

Using Winsor blue red shade, start to indicate the directions of wave movement in the foreground of the picture, leaving areas of clear water. When the paint is dry, use a soft putty eraser to rub off the various areas of splatter protected by masking fluid.

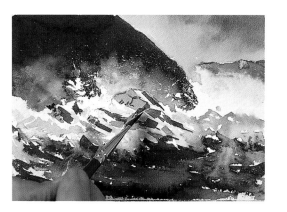

step 5

Start to model the highlighted rocks in the foreground, using French ultramarine and burnt umber and a No. 6 round brush to show the various cracks and the sides of the rocks that are against the light.

step 6

With the No. 16 round brush, keep modelling the water, using Winsor blue green shade with a touch of cadmium lemon to get the turquoise effect of translucent water. With raw sienna and burnt umber, paint in the rock to the right-hand side of the picture. Model the main rock further with the No. 6 round brush, and use a pale mix of French ultramarine and burnt umber to indicate the water as it falls back off the rocks again and into the sea.

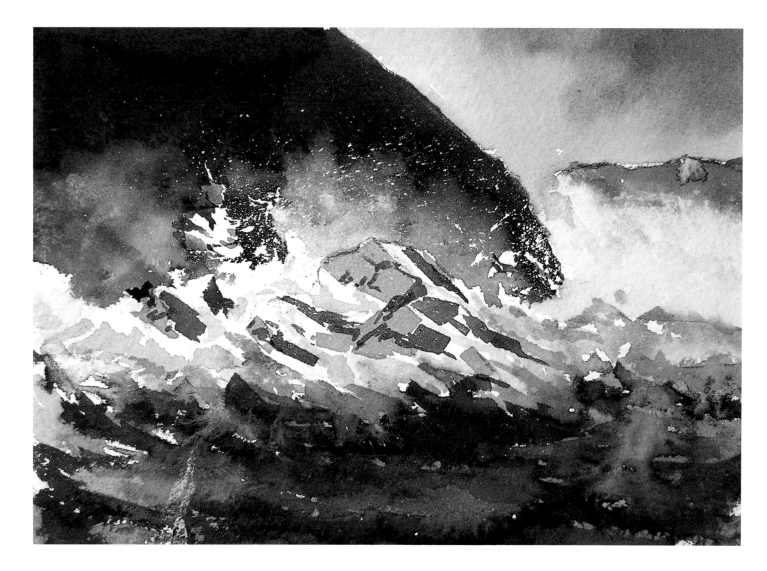

moody sea

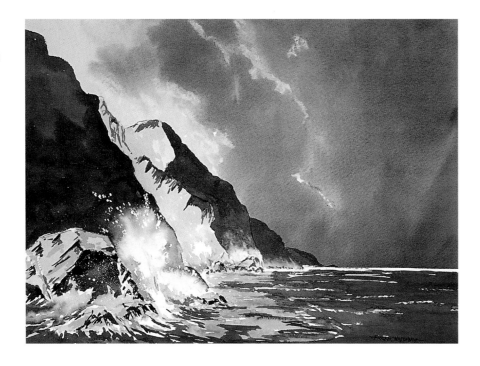

We have now completed the various approaches to different kinds of water and strong, lively skies. Let's now put them into practice in this Sunday painting of a rugged coastline with a strong storm cloud approaching from the right, making a contrast with bright sunlight losing the battle with the ominous sky. Don't be nervous about the strong contrasting values in this picture – just go for it; you will be over the moon when it works!

YOU WILL NEED

Colours

- raw sienna
- Winsor blue green shade
- Winsor blue red shade
- burnt umber
- light red
- cobalt blue
- white gouache

Brushes

- No. 16 round (for washes and large areas)
- No. 6 round (for general detailed work)
- No. 3 rigger (for fine detail)

Paper and other equipment

- Winsor & Newton Lana Aquarelle Rough 600gsm (300lb) or Winsor & Newton Lana Aquarelle Rough 300gsm (140lb), which will need stretching
- masking fluid
- masking tape
- old toothbrush
- old worn paintbrush
- soft putty eraser
- 4B pencil
- tissue
- craft knife

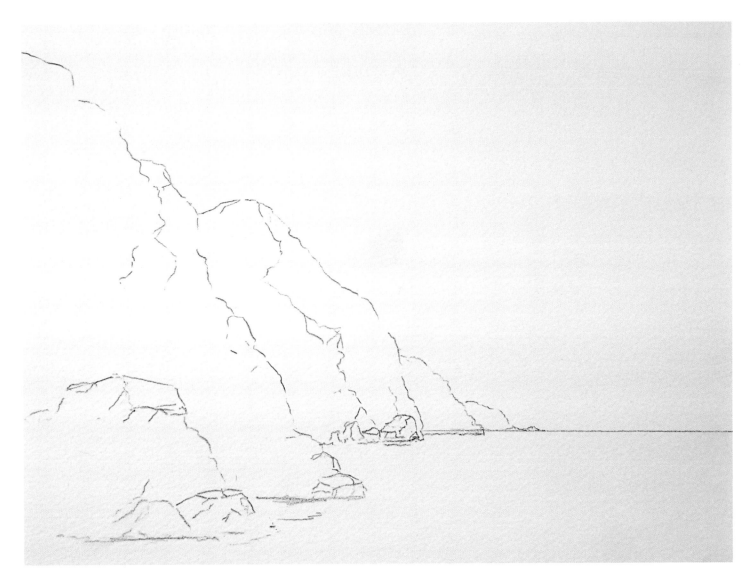

INITIAL DRAWING

You will see from the sketch that I used very few lines to convey the cliff formation. The cliffs, which are roughly the same size (excluding the small outcrop in the foreground), obey the rules of perspective, appearing smaller as they recede into the distance (see page 26). Ensure that your horizon line is level – you don't want the sea to go uphill!

step 1

With a strip of masking tape, mask out below the line where the sky meets the sea. Then mask out the highlighted foreground rocks with masking fluid and an old paintbrush. Drag a craft knife along the bristles of an old toothbrush loaded with masking fluid to create spray as the waves hit the rocks.

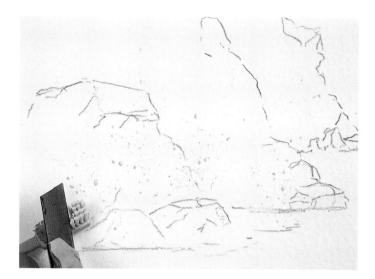

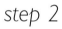

step 2

Make up separate washes of raw sienna and cobalt blue, plus a strong mix of cobalt blue and light red to create a dark blue-grey. Use a No. 16 round brush to wash the whole sky with raw sienna, allowing it to come down onto the highlighted areas of the cliffs. Rinse the brush, load with cobalt blue, and paint over the sienna from the top right; stop before you reach the cliffs to retain the light sky over them.

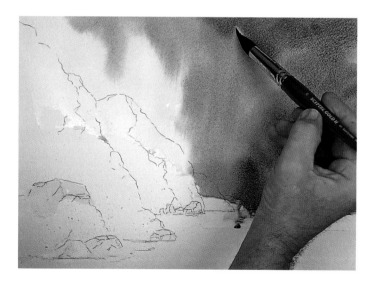

step 3

With everything still quite wet, load the same brush again with the mix of cobalt blue and light red. Starting at the top right, create dark cloud shapes, leaving areas of blue showing through. Use a tissue to wipe out the overlying darks, revealing a raw sienna highlight on the edge of the cloud. Leave to dry.

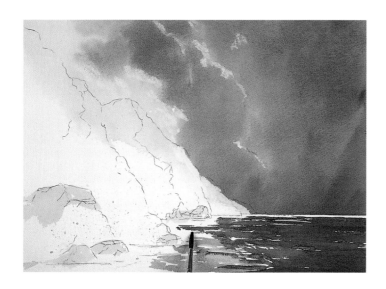

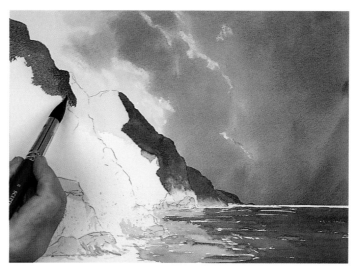

step 5

Using a strong mix of cobalt blue and light red, start painting the distant headland with the No. 16 round – soften the mix with water to indicate spray at sea level. Carry on painting the cliffs, getting progressively stronger as you come to the front; again lose the colour in the sea spray. Add the strongest large cliff, starting top left and avoiding the highlighted rock face painted earlier.

step 4

Remove the masking tape from the horizon and, using the sky colours, start painting the sea, first with the blue then overlaying it with the dark grey; take care to leave a narrow band of white paper to represent sunlight shining on the distant sea. As you come towards the fore-ground cliffs, use a No. 3 rigger to introduce a weak mix of Winsor blue green shade and Winsor blue red shade around the base of the rocks to give depth to the sea here.

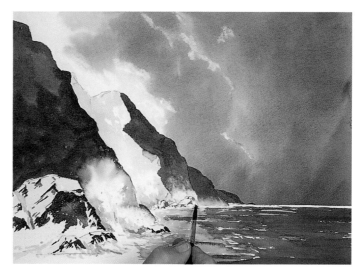

step 6

Finish painting the foreground cliff, losing it in the spray at the bottom by painting with virtually clean water. Add a little burnt umber to the cloud mix to darken and warm the colour for the shadow sides of the front rocks at the base of the cliffs, using the No. 3 rigger.

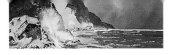
step 7

Use a strong mix of raw sienna to give the impression of shape on the cliffs and rocks facing the sun with a No. 6 round brush. Use the darker mix for the foreground rocks, slightly weakened, to sculpt the cracks and crevices of the sunlit cliffs and rocks.

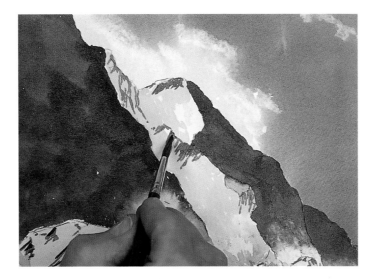

step 8

Remove the masking fluid with a putty eraser to reveal the protected areas of spray and splashes. Using a very weak mix of the cloud colour, soften the stark edges of the areas which were covered by the masking fluid; this will give shape and roundness to the crashing wave and the foam running off the rocks. If you need more spray and splatter, add more marks using white gouache, an opaque white that covers dark areas.

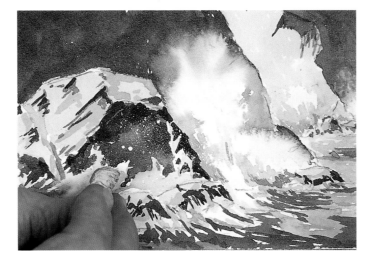

FINISHED PAINTING

250 x 350mm (10 x 13¾in)

Congratulations on painting a lovely picture! All you need to do now is to sign it and to get it framed. Remember to use strong colours and contrasts to create drama, and use the crashing waves to give it punch. Site the centre of interest, in this case the crashing wave, on one of the thirds for a good composition. Use this formula for a different seascape using the same techniques, and try other colour combinations.

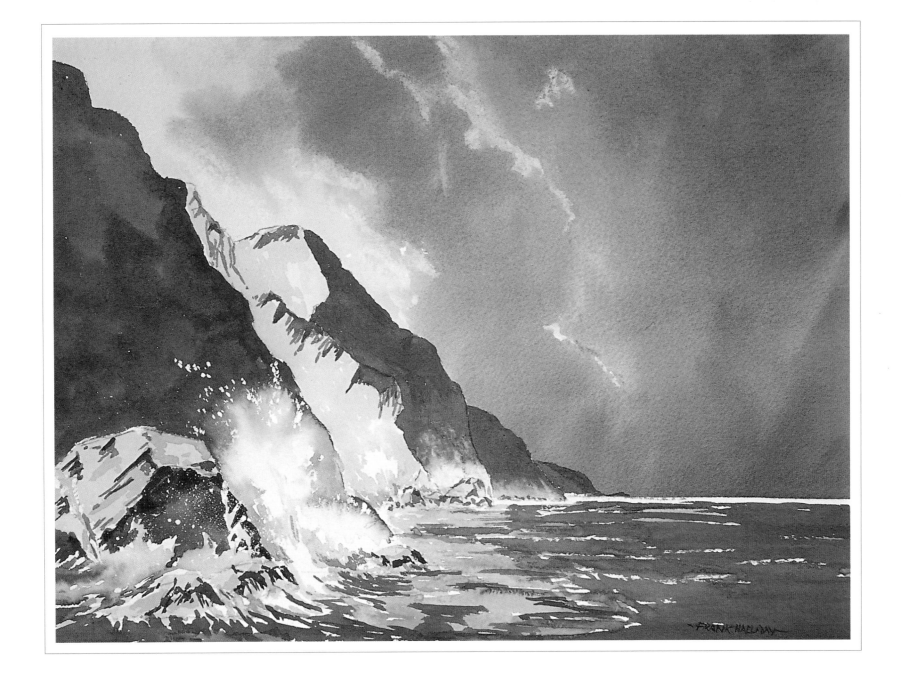

project 3 · mountains and lakes

This project looks at beautiful mountains and lakes. First of all, you need to familiarize yourself with the characteristics of mountains and do several exercises at different times of the year.

A question I am often asked is, 'How do you paint that mist which swirls around tops of mountains?' The answer to this is in exercise 2, when we do a step-by-step exercise of painting mist on mountains.

Before you understand how mountains are structured, we need to look at how to make them recede into the background to create a three-dimensional effect. This simple exercise enables you to do that.

exercise 1: tonal recession

step 1

Use a No. 6 round brush for this exercise. Sketch out the mountain range and paint over the whole scene with a wash of cobalt blue. Leave to dry, and then use a slightly darker wash of the same colour to paint over the four mountains. Leave to dry.

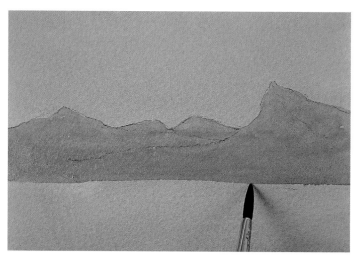

step 2

Using the same cobalt blue mix, paint over the three mountains closest to you and let this dry. Each wash dries to build up a subtle layer of tones, working from light to dark.

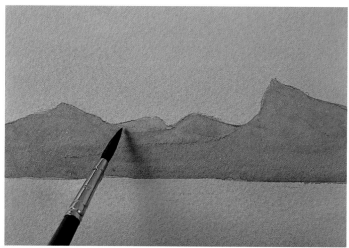

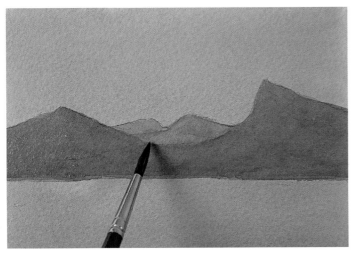

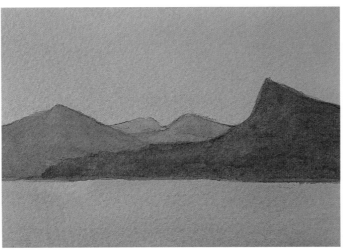

step 4

Paint over the foreground mountain with the cobalt blue, allow to dry and then introduce a touch of raw sienna into the mix; this adds green to the mountain, warming it and bringing it forwards. Allow to dry again.

step 3

Using the same mix again, paint over the two closest mountains and leave to dry. You will now see the effect of tonal recession, or aerial perspective (see page 26), starting to take place. The tones decrease in strength as an object recedes away from the viewer.

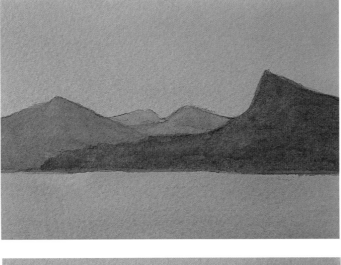

step 5

Use a dark mix to give shape to the areas of rocks on the nearest mountain. To finish, apply a dark mix of cobalt blue drybrush across the lake to indicate sparkle on the water.

mountain structure

CASTLE OF VERDUZ, LIECHTENSTEIN

In this study of mountains I painted the sky with a No. 16 round brush in Winsor blue red shade. Then I applied a wash over the mountains and rocks beneath the castle with raw sienna. With a mix of raw sienna and French ultramarine, I painted the trees around the castle and down into the valley, varying the strength of the mix to give some tonal range. The foreground hill was painted with a mix of cadmium yellow and Winsor blue red shade. Once the initial washes had dried, I started to sculpt the mountain, using a No. 6 round brush and several earth colours. I started with burnt sienna then burnt umber, using light tones on the right-hand side, facing the light. I added the castle roofs and the tiny house with a mix of cadmium yellow and Winsor red, making them darker against the light. I added the shadows to the left-hand side of the mountain to give it shape. Look carefully at the structure of the mountain – what I call the backbone – this ridge runs along the top of the mountain. The shorter, jagged ridges radiating from it I call the ribs. They are often irregular in shape with deep crevices full of shadow. You will find that most mountains are structured in this manner.

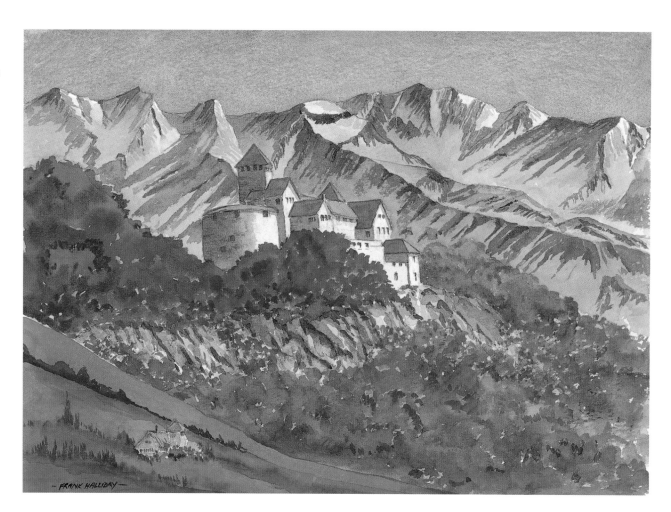

snow

STILL A LONG WAY TO GO

In this mountain study I painted the sky in raw sienna with cobalt blue, and dropped light red into the wash to give a wet-in-wet effect. This allows the darkness to emphasize the raw sienna light set against the backdrop of the mountains. The light is coming from the right-hand side, and I indicated the reflection of the sunlit sky on the faces of the mountain. I painted the tones of the mountain in cobalt blue and light red, which gives a dark brown-blue colour to the areas of mountain that are not covered in snow, and painted the shadow areas of the mountains in a pale wash of cobalt, with a touch of light red to make a gentle grey. This throws the mountains into three-dimensional mode by indicating the shadows.

I used aerial perspective to create a three-dimensional look by making the distant mountains much paler than the important foreground mountain. On the outcrop of rock in the immediate foreground on the left, I added a collection of four tiny figures to give the whole picture an element of scale.

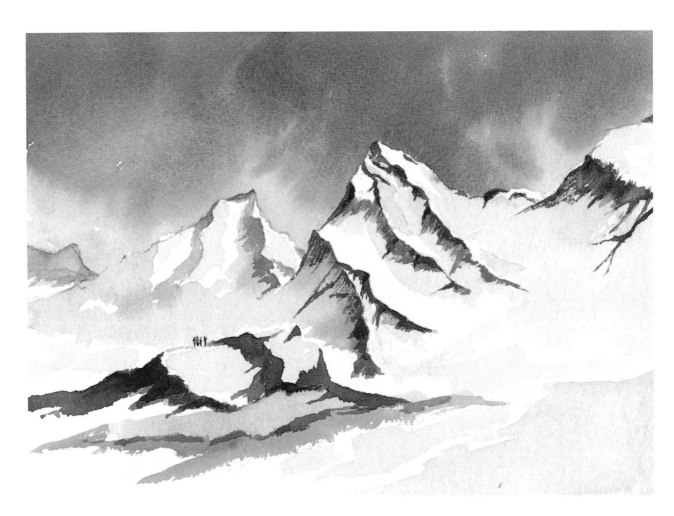

exercise 2: misty mountains

step 1

Use a No. 6 round brush for this exercise. First, sketch the mountains and paint the sky with a wash of French ultramarine, leaving areas of white paper to show as wispy clouds. Add burnt umber to the wash for a dark cloud in the top right-hand corner. Dilute the mix at the left-hand side and bring this down to the base of the front mountain, sculpting the cloud formation on the left.

step 2

Use a mix of French ultramarine and burnt umber to start the foreground mountain. Paint the tip and leave an area of clear colour, then move down the left-hand side of the mountain in stronger colours so as to give the impression of mist swirling all around the foreground mountain. Soften the strong areas of colour on the mountain with a tissue and clean water.

step 3

Continue adding detail to the foreground mountain with a paler wash of the mix from Step 2. Paint in the background peak of the second mountain to the left, leaving the strong colour high on the mountain. Then use clean water and a tissue to soften the edge to give the impression of mist around the second mountain and into the valley. With raw sienna and French ultramarine, paint in the area of greenery which reaches up the sides of the foreground mountain – this is called the tree line, because above this line very little grows and trees can't survive.

step 4

Use a dark mix of French ultramarine and burnt umber to pick out the outline of the mountain in a stronger tone against the sky; this separates the colour of the mountain from the sky and brings the foreground mountain further forward. Continue to shape and sculpt the mountain in the foreground just above the tree line.

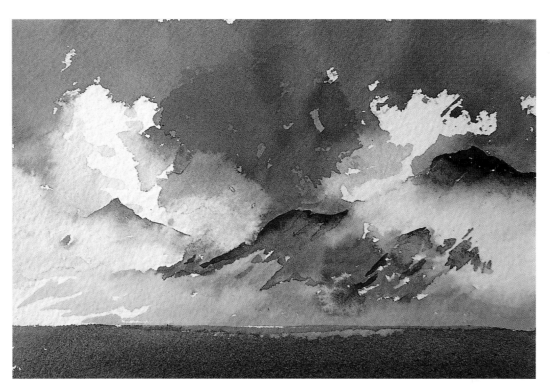

step 5

With a similar mix, paint in the foreground lake, leaving areas of a lighter colour close to the mountain. The important thing to remember on painting misty mountains is the area of mist you don't paint at all; just indicate stronger tones of mountain in a broken line in a lost and found technique to show where the mist level is around the mountain. You can also use this technique to paint a morning scene across an area of fields where a river is involved. Mist tends to lie about 1m (3ft) above the level of a field in a band of very little colour at all, but you get the indication of the tops of hedgerows and trees as though they are floating on air.

early morning by the lake

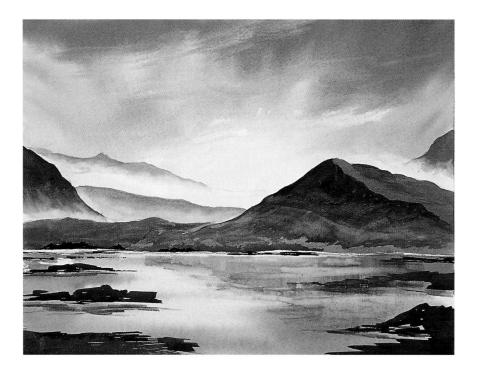

After working our way through different types of water and mountains, I now give you a chance to capture a very quiet and still early morning close to the lakes and hillsides. The sun is just waking up and starting to burn through the mist in the valleys as the rays increase in warmth. It has the look of a really fine day ahead. Let's get our equipment and capture the moment.

YOU WILL NEED

Colours
- raw sienna
- French ultramarine
- burnt umber
- alizarin crimson
- burnt sienna

Brushes
- 25mm (1in) flat brush (for all-over washes)
- No. 16 round (for large areas)
- No. 6 round (for general detailed work)
- stiff bristle brush (for scrubbing out the reflections)

Paper and other equipment
- Winsor & Newton Lana Aquarelle Rough 600gsm (300lb) or Winsor & Newton Lana Aquarelle Rough 300gsm (140lb), which will need stretching
- soft putty eraser
- 4B pencil

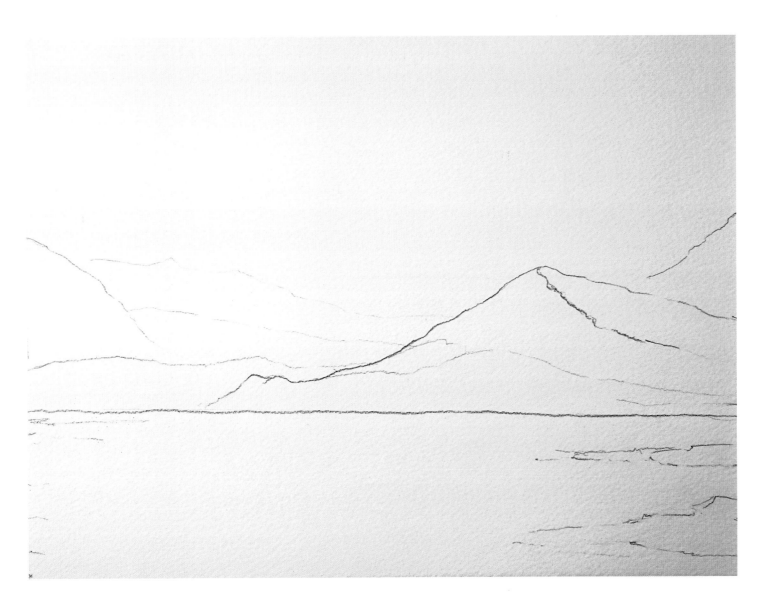

INITIAL DRAWING

Use very few lines in this sketch, as it is a simply stated painting. Place the lake one third up the picture plane, as you do not want to appear to be cutting the picture in half by placing it halfway up.

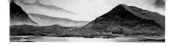

step 1

Wet the paper all over with clean water using a 25mm (1in) wash brush. Mix a wash of raw sienna across the central area of sky and down into the central lake area. While still wet, paint a mix of French ultramarine and burnt umber into the sky with a No. 16 round brush.

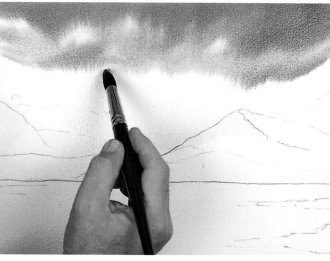

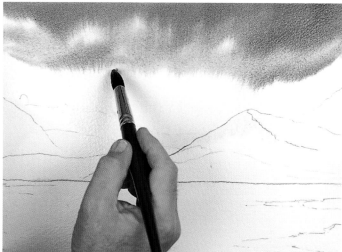

step 2

Using a crumpled piece of tissue, lift out the blue colour in the sky in a diagonal movement to reveal the underlying wash of raw sienna. If done carefully, this will give the impression of wispy clouds across the sky.

step 3

Paint the lake with the raw sienna wash and No. 16 round brush. Add a little alizarin crimson to the sky mix from Step 1, and paint over the lake in a wet-in-wet method, avoiding the sunlit areas. Leave the picture to dry.

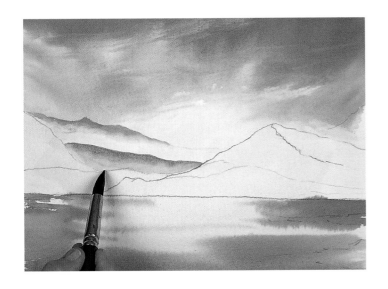

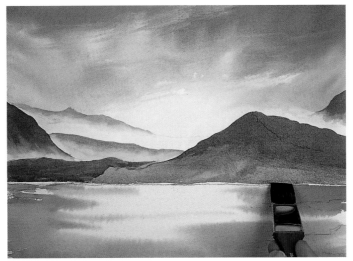

step 5

Using the same palette but stronger mixes, and adding more French ultramarine, paint the tops of the mountains at the far left and extreme right, using the softening technique to show the mist. Then, with a stronger mix, adding a little burnt umber, paint the darkest foreground mountain with the 25mm (1in) flat brush right down to the water's edge.

step 4

Using a weakened mix of the blue used in the lake, paint in the distant mountain, blending it at the bottom with clean water to lose the colour and indicate mist. Add a little burnt umber to this mix and repeat the process on the low hill in the centre.

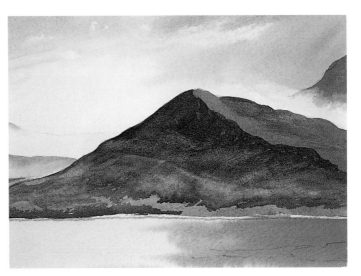

step 6

Again, strengthen the mix and sculpt the shadowy face of the large mountain. With a mix of French ultramarine and raw sienna, shape the tones of green where the lower growth starts at the tree line. Along the left-hand shore, indicate a few dark details, which could be bushes.

step 7

Start to place the rocks in the lake using the strong blue mix of the front mountain from Step 5 – remember that perspective takes over here, and so the background rocks will be smaller than those at the front. Bring the closest one at bottom right forward by adding a little burnt umber to the mix.

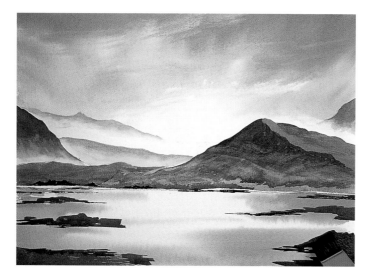

step 8

The final task is to mirror the large mountain into the lake by using a weaker version of the same colour. The reason for this is that darker objects appear lighter in water and lighter objects are darker, which has the effect of reducing the contrast between them. As you paint the mirrored image, take a stiff brush and lift out lines of light where the sky is reflected into the water.

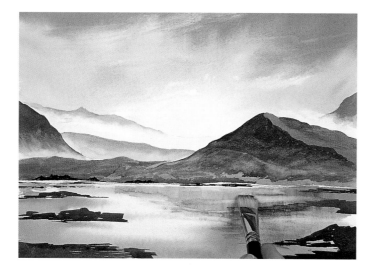

FINISHED PAINTING

250 x 350mm (10 x 13³⁄₄in)

If your picture gives you the feeling of being the only one for miles around to be drinking in the beauty and stillness of this lovely view, give yourself a pat on the back – and then get moving straight on to the next project!

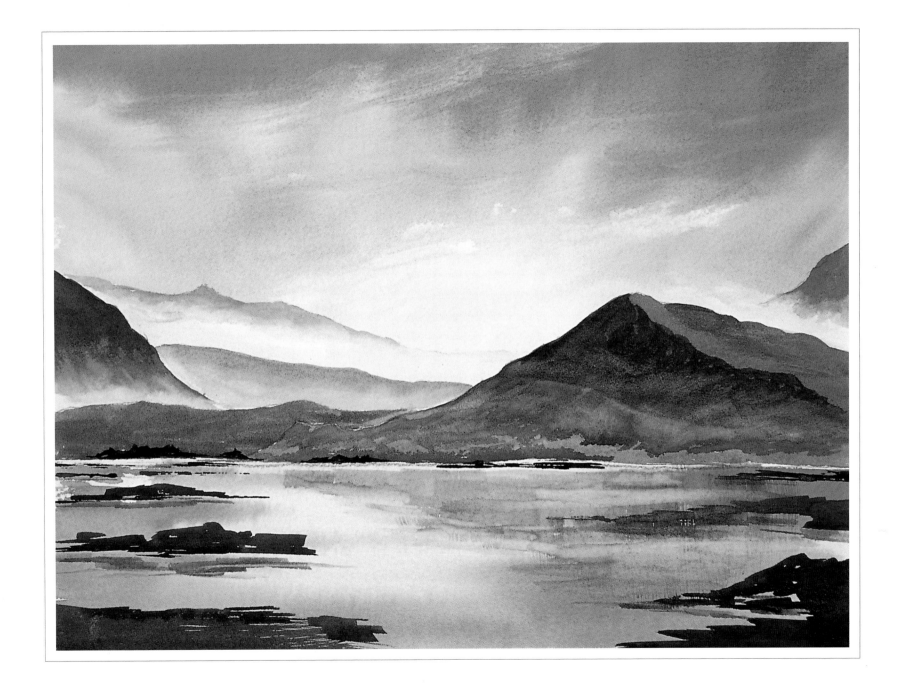

project 4 · trees and foliage

Trees are an essential part of a landscape painter's portfolio, and you can now share my approach and develop the same skills. By a general rule of thumb, unless you are making an individual study of a specific tree, you can generalize their shapes – you will soon come to recognize common forms. Try to remember that the shape of the trunk and branches is often mirrored by the tree's foliage in summer.

People viewing your painting should see trees as part of your landscape, and hopefully not be asking you the Latin names of each type!

exercise 1: winter tree

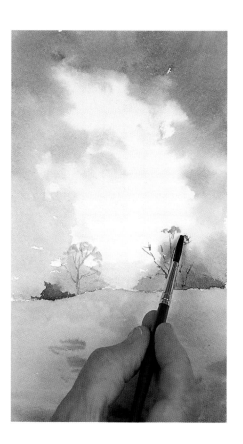

step 1

Mix French ultramarine with a touch of burnt umber. Wet the sky area with clean water and drop the mixed colour into this wet in wet, starting at the top with a No. 16 round brush; as you come towards the horizon add a little alizarin crimson. Using a slightly stronger mix of the same colour, just before the sky fully dries, place in distant trees, then use burnt umber to suggest the next layer of distant trees; do the same again with burnt sienna. Use a No. 6 round brush to paint in the actual distant tree shapes and show a few fine twigs.

step 2

When dry, paint in the grass area with cadmium yellow plus French ultramarine. Paint the foreground tree from the bottom upwards with raw sienna and a No. 6 round brush, then add the shadowed side to the right with the sky colour while still wet, to give roundness to the tree. For the finer branches, switch to Nos 1 and 3 rigger brushes, which are ideal.

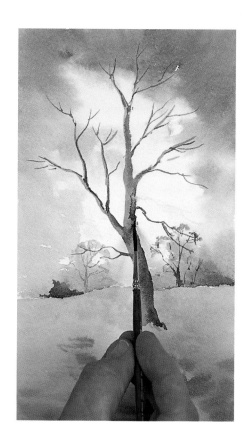

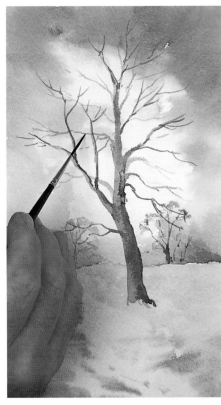

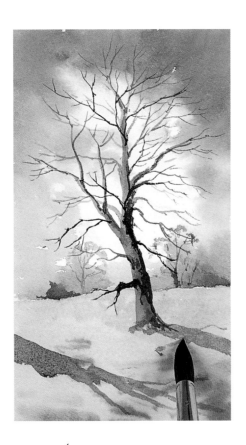

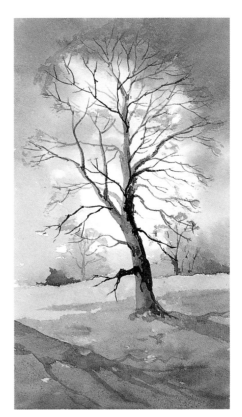

step 3

Roundness, or form, on a flat, two-dimensional sheet of paper can be achieved by using tonal recession. Using the riggers, paint some branches a pale sky colour to make them appear as though they are going back away from the tree, and then paint some branches in stronger and warmer tones to bring them in front of the tree.

step 4

Using the No. 16 round brush, indicate the direction of light from the left by adding the tree's cast shadow with French ultramarine plus a little burnt umber; this anchors the tree to the ground and brings the bottom of the picture towards you. Add a shadow from a tree off-picture to the left.

step 5

To finish the picture, add very fine twigs around the tops of the branches, which are impossible to paint individually. The way to suggest them is to take a little of the shadow colour and use a drybrush technique, gently sweeping the side of the No. 6 round brush in an arc movement along the tops of the branches.

69

exercise 2: foliage

step 1

Paint the sky, first with clean water, then a wash of French ultramarine using a No. 16 round brush. While wet, lift out areas for the leaves with a wet sponge. Mix cadmium lemon with French ultramarine – mix more than you think you will need, as a sponge absorbs plenty of liquid – and dip a sponge into the mix and stipple this onto the sky to represent the light foliage. Take care not to overdo this.

step 2

Make another mix of cadmium lemon and French ultramarine, with more blue to darken the green, and use the same action to sponge darker areas. The position is determined by the direction of light, which will indicate shadow areas. Vary the strength of the darks to give variation in tones.

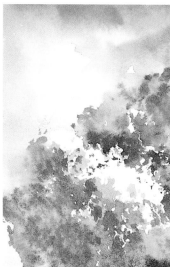

step 3

When the sponging is dry, use raw sienna to paint in the branches. Use the dark green to indicate the shadow side of the branches while the first colour is still wet. This will then blend into the raw sienna, making the branches appear round.

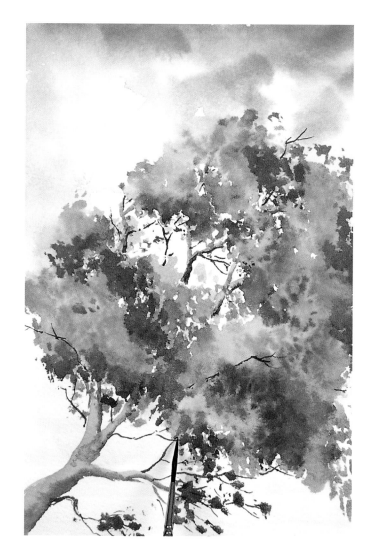

tree shapes

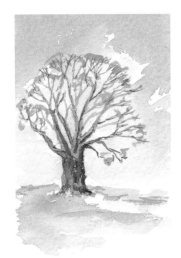

Sycamore in winter

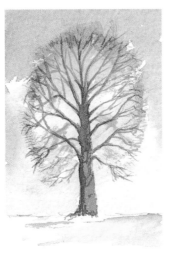

Horse chestnut in winter

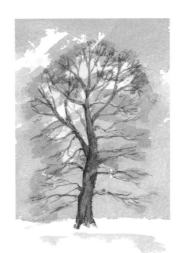

Oak in winter

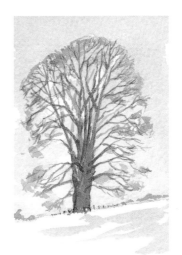

Lime in winter

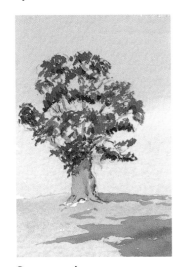

Sycamore in summer

Horse chestnut in summer

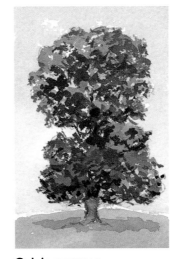

Oak in summer

Lime in summer

SEASONAL CHANGES

Before you think I am going to go all botanical, I would just like to show you some small studies of native trees to illustrate general shapes, in winter and summer. I painted these with a No. 6 round brush and a No. 3 rigger for the small branches. When making studies of trees, look at the structure. The best time to observe trees is in winter, when the magnificent framework is exposed. Try sketching them from the warmth of a car, then take the sketches home and imagine them in summer, clothed in leaves. Don't forget that in some of your pictures a tree may be the focal point, and to know a little about it will help you make a better painting. The main thing to remember is to try to render the shape accurately; then your painting will look convincing.

trees in a setting

BUXTON WATERMILL, NORFOLK

This is a lovely spot, close to my home, that has everything – beautiful trees in different stages of maturity and colour, buildings, water, reflections and an old bridge.

I used French ultramarine for the sky, adding burnt umber for the clouds in the lower sky to set the dark against the white of the mill. I placed the background trees to frame the mill and contrasted them against the complementary colours of the light red roofs at the side. The background trees were mixed from French ultramarine and raw sienna, and I substituted cadmium yellow for the raw sienna on the closer trees.

For the foreground trees, I used cadmium yellow and Winsor blue red shade, and diluted this mix for the riverbanks. I washed in the bridge with raw sienna and burnt sienna, adding French ultramarine and light red while still wet to age the brickwork. The small plum tree at bottom right was painted with alizarin crimson subdued with French ultramarine. All the trees have holes in them where the mill shows through. I reflected the individual colours of the trees in the river, along with part of the mill.

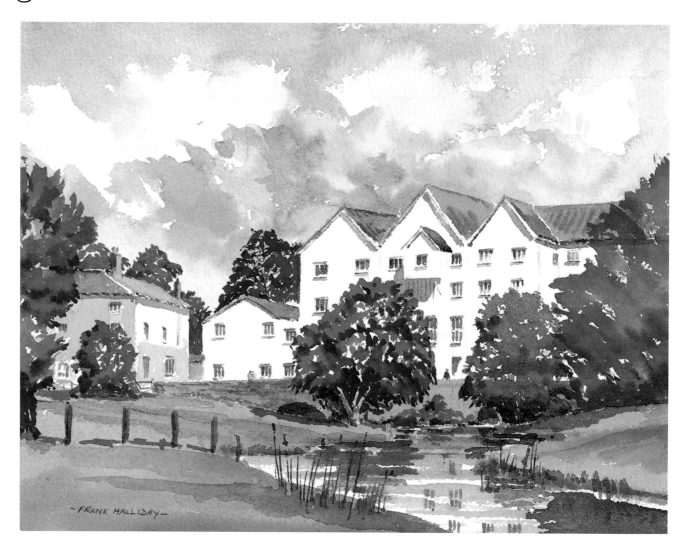

autumn trees

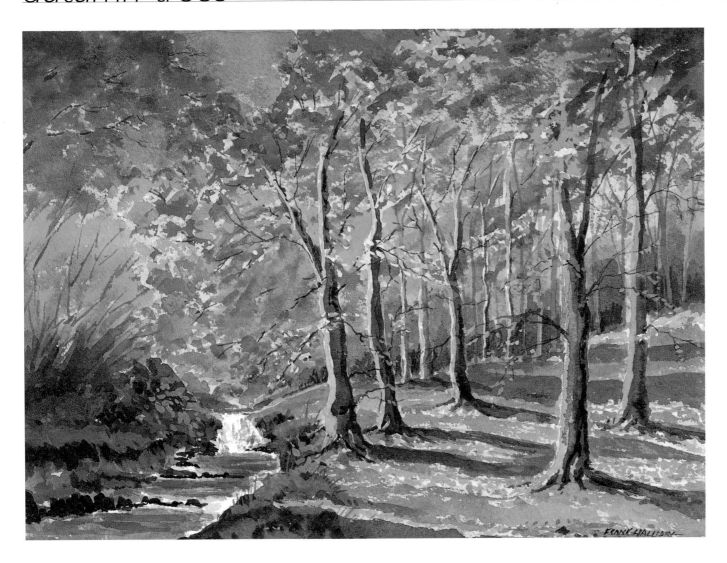

QUIET STREAM

When you first look at this picture you may think, 'Where do I start?'. After the initial sketch, I masked out the tree trunks and the highlights in the stream with masking fluid. I washed the whole picture with raw sienna and, while still wet, dropped in burnt sienna and burnt umber for the foliage mass.

I let it dry and then used French ultramarine to show a glimpse of sky, and painted in the stream, leaving white paper for highlights. Then I used the same browns drybrushed to overlay a selection of suggested individual leaves. I rubbed the masking fluid from the trees, leaving some of the background silver birch saplings white. I then painted the other tree trunks with the browns, and introduced French ultramarine into the shadow side on the right.

Using a strong mix of French ultramarine and burnt umber, I added side branches and twigs. Weakening the same mix, I indicated the shadows on the left-hand bank of the stream and from each tree.

the morning walk

This is a scene many people with a dog will have experienced, when the early morning light filters through the trees and no one is up and about. In this Sunday painting you use three of the mediums discussed in the **Basic Techniques** section – **Lifting Preparation**, which allows you to choose at the end of the painting where you want the shafts of sunlight to be placed; **Permanent Masking Fluid** to permanently protect the colours of the trees when you paint in darker colours; and masking fluid to temporarily protect the areas of sun on the road. Sometimes your paintings need to be fresh and immediate, letting the mood lead you, or, as in this case, a pre-planned work means you dictate what is going to happen and when.

YOU WILL NEED

Colours
- raw sienna
- French ultramarine
- burnt umber
- cadmium yellow
- burnt sienna
- cobalt blue
- cadmium lemon
- Winsor blue red shade

Brushes
- Nos 16, 10 and 6 round
- 12mm (½in) flat bristle
- Nos 3 and 1 riggers

Paper and other equipment
- Winsor & Newton Lana Aquarelle Rough 600gsm (300lb) or Winsor & Newton Lana Aquarelle Rough 300gsm (140lb), which will need stretching
- Lifting Preparation
- Permanent Masking Medium
- masking fluid
- mapping pen
- soft putty eraser
- 4B pencil
- drawing pin
- straight edge

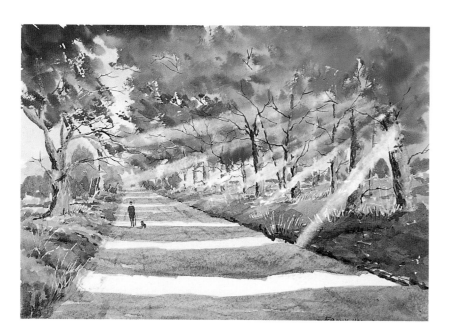

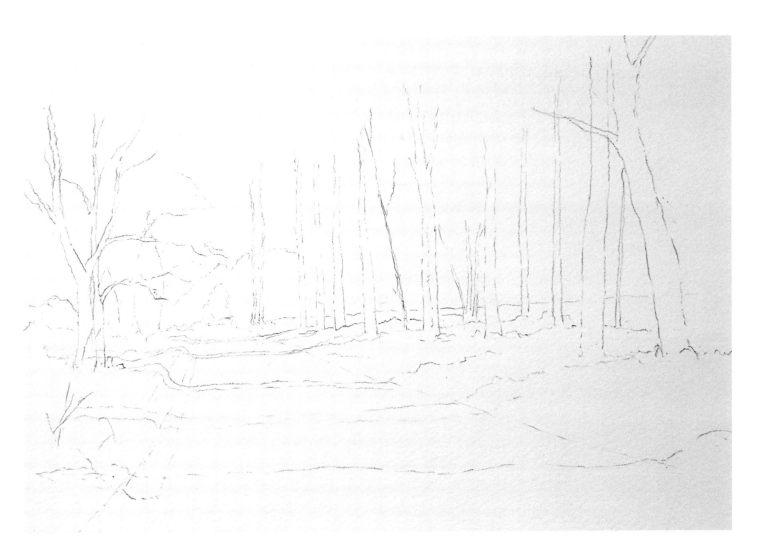

INITIAL DRAWING

In this sketch, I simplified the original scene by drastically reducing the number of trees, as I really could not see the wood for the trees! It is quite acceptable to select and discard elements of a scene – to make your life easier and your composition better!

step 1

Having sketched out the picture, pour out sufficient Lifting Preparation to coat the whole of the picture area. Use a No. 16 round brush to paint this colourless liquid all over the paper. When dry, paint the trees with clear Permanent Masking Medium. Use the mapping pen to apply masking fluid to protect the sunlit areas of the woodlands and the road.

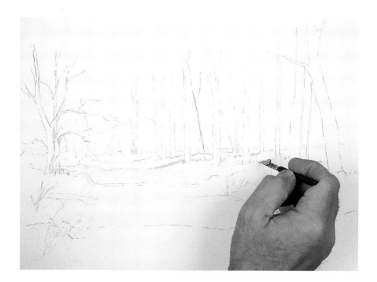

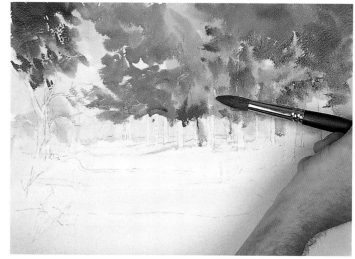

step 2

Paint a wash of raw sienna over the whole picture. Drop cobalt blue wet in wet in the areas where the sky shows through.

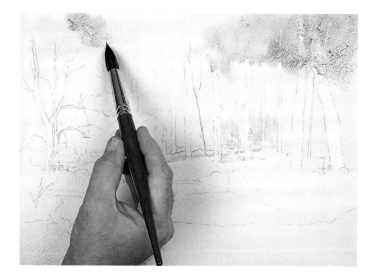

step 3

Mix cobalt blue and cadmium lemon to paint the sunlit tree areas, increasing the cobalt blue to darken some of the leafy branches. Leave to dry and then use cadmium yellow and Winsor blue red shade to vary the leaf colours. Darken this mix by adding more Winsor blue red shade, and use a No. 16 round brush to roll in small parts to indicate a few individual leaves.

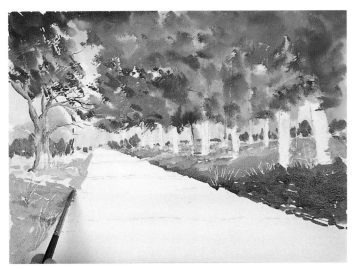

step 5

Paint strips of sunlight across the woods with cadmium lemon and a touch of cobalt blue, then use a No. 6 round brush with burnt sienna to paint the foreground roadsides, varying the tones and textures by adding French ultramarine. The light is coming from the right so the bank on the right-hand side will be darker. Indicate shadows in the woods with French ultramarine and burnt umber.

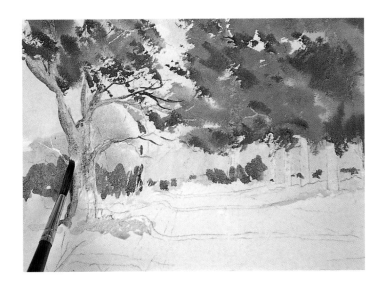

step 4

Using a No. 10 round brush, paint the distant trees and hedges with a cool green made of cobalt blue and raw sienna, and use cadmium lemon and a little Winsor blue red shade to show where the sun catches the grasses in the woodland. Start painting the tree on the left with raw sienna, and darken the shadow side with French ultramarine and burnt umber.

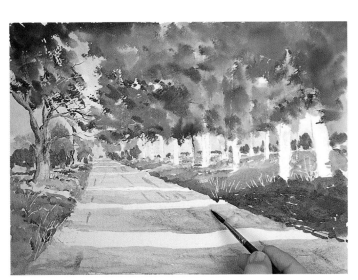

step 6

Use the same mix to place the shadows cast across the road, continuing these onto the grassy bank on the left, following the contours. Start at the nearest ones, the strongest in tone, and reduce the tonal strength for the shadows further away to give the impression of recession. With the same mix, show track marks along the road to lead the eye into the painting.

step 7

For the shafts of sunlight, stick a drawing pin in at the top right of your board and rest the straight edge on top of this. Holding the left side of the straight edge, dip the flat bristle brush into clean water and run it along the underside of the straight edge, taking out the Lifting Preparation. Clean the brush, move the straight edge further up, and repeat the process.

step 8

Using the mixes for the left-hand tree in Step 4, paint the right-hand tree trunks protected by Permanent Masking Medium, but only in the areas that the shafts of light do not strike. Using the putty eraser, take off the temporary masking fluid to reveal the highlighted grasses.

step 9

Concentrate on the grasses, using cadmium yellow and a little Winsor blue red shade to produce an opaque bright green to sculpt the tufts and undulating woodland. Darken the shadow area along the right-hand side of the road with French ultramarine and burnt umber. Add a touch of burnt sienna to the sunlit tree on the left, and run this into the soil at the foot of the trunk.

FINISHED PAINTING

250 x 350mm (10 x 13¾in)

All that remains to complete the picture is to paint a few dark branches over the shafts of light to show that the light is coming through the trees, and not over the top. Add the small figure holding a piece of branch and the dog waiting patiently for him to throw it.

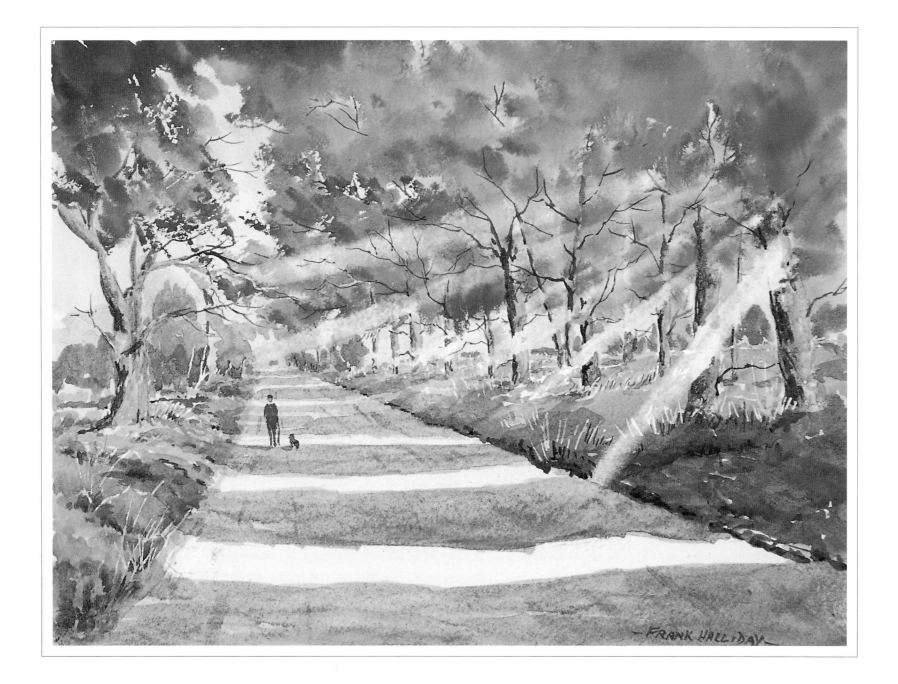

project 5 · buildings and textures

In this section on buildings and textures, I want you to consider the structures of buildings – you can only paint so many trees, lakes, hills and mountains before you include this subject.

I do not want to get you heavily involved with perspective, as this tends to put people off including buildings, but you should try to absorb enough to make you happy about including a building or two. Later in this section I show the Texture Medium in action, as discussed on page 19.

linear perspective

SPANISH DOORWAY

This is an example where one-point perspective helps to render accurately the angles of the steps and door. The far sides of the steps appear to get closer together as they go away from you, and the slant of the doorway also adds to the subtle impression of three dimensions. By lightly drawing imaginary lines extending from the top and bottom of the steps and doorway, you can see that all the lines will converge at one place on your eye level – the vanishing point. The lines from the steps above eye level go down to the vanishing point, and the steps below eye level go up. As the whole of the door is above your eyes, all the lines come down to the vanishing point. By following the slope of these converging lines, you will render perspective more accurately.

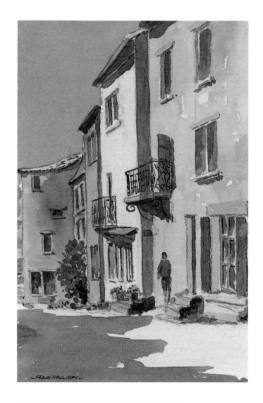

SAULT, PROVENCE, FRANCE

I painted this study while tutoring a group of painters in the South of France. The perspective, although not completely accurate, is sufficiently close to be acceptable. Each building has its own vanishing point; the one at the end is facing round the corner and the lines would converge at a totally different place. By showing this, the viewer can assume that the road turns to the left at the end.

exercise 1: light and shade

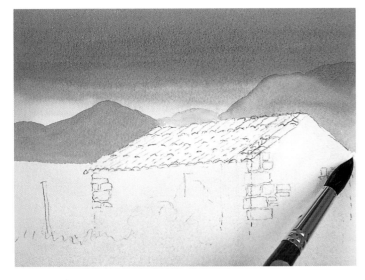

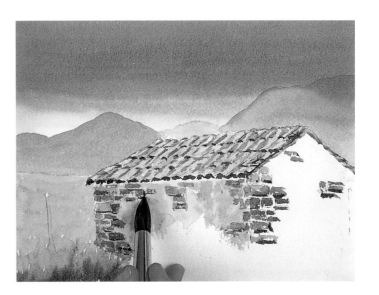

step 2

Make up separate mixes of burnt sienna, raw umber, burnt umber and French ultramarine. Wash the whole building with a base coat of raw sienna, then drop in a variety of these colours. When dry, paint some of the individual rough stones. Treat the pantile roof in the same manner, sculpting the shapes of the tiles with a darker colour.

step 1

A building can be made to be more three-dimensional by the use of light and shade. Here, the perspective comes from the corner of the building and the front corner appears higher than the two side ones. If you hold a pencil along the top of the roof you will discover that the roofline falls away to your left down to the eye level, obeying the rules of perspective. Use Winsor blue red shade and a No. 16 round brush to paint in the sky with a graduated wash. When dry, use the same mix to paint in the distant mountains.

step 3

With a strong mix of French ultramarine and burnt umber, paint in the doorway, then weaken this mix and paint the right-hand end of the building with a No. 6 round brush – the darkest shadow is near the sunlit side and as the shadowed wall moves away, it picks up reflected light from the surrounding area. Use the same mix to place the shadow under the eaves, and paint in scrubby grasses to anchor the shelter.

81

project 5

exercise 2: simple brickwork

CHIMNEY DETAIL

The little vignette of the chimneystack below was painted with a small flat brush. I wanted it to look like a new structure, so the modern bricks are tonally similar. As discussed in the last two exercises, perspective and light and shade are used to make the stack look solid.

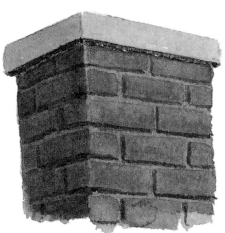

step 1

An old plastered wall, cracked to reveal the underlying brickwork, is a terrific opportunity to try out Texture Medium – just the job for anything weathered and worn. Mix small quantities of burnt sienna, raw umber, burnt umber and French ultramarine, then wash the whole paper with raw sienna using a No. 16 round brush. With a No. 6 round, drop in the colours in a loose pattern of bricks in an irregular shape in the centre.

step 2

Allow to dry, then use a 15mm (⅜in) chisel brush to paint rectangles in a line, to complete the exposed brick area. Use the colours from Step 1, and remember that as you approach the misshapen edge only partial bricks will be visible.

step 3

To the various mixtures used for the bricks, add a little Texture Medium and randomly paint the old plasterwork using a No. 16 round brush – you can see how it separates and creates a super 'old' impression. Using French ultramarine and burnt umber, make a start on where the plaster is cracking and falling off the wall with a No. 3 rigger.

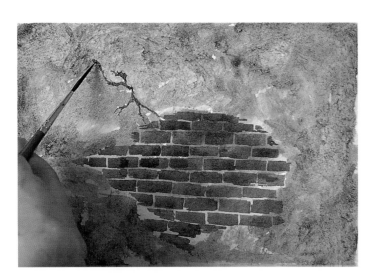

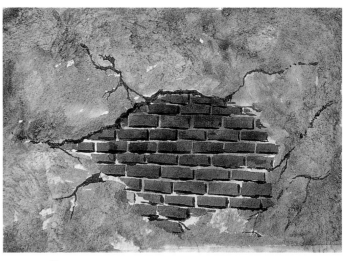

step 4

Continue to suggest cracks that vary in width and length, using the chisel brush. Look for the colour changes on your random treatment on the plaster with the Texture Medium, and if one piece is lighter than another, paint a crack along the difference. Paint lighter, smaller cracks branching off.

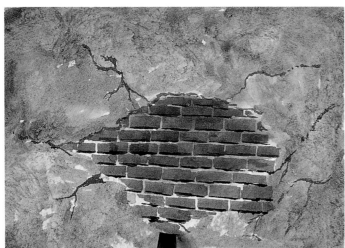

step 5

Even in a small vignette like this, remember that light and shade play an important part. With the light from top left, you now have to consider where the shadows will be, even on a surface that appears basically flat. Paint under the top side of the plasterwork with French ultramarine and burnt umber, and use the chisel brush to darken the underside of most of the bricks; because the light is from the left, the right-hand side of each brick needs the same treatment.

windows

CLOSE-UP STUDY

When painting buildings we have to include windows. Look for reflections and colours showing through; suggest part of a curtain or even a vase, and your windows will improve. The window below caught my eye as it did not show me what was through the glass, but what was reflected in it: sky, branches and bushes.

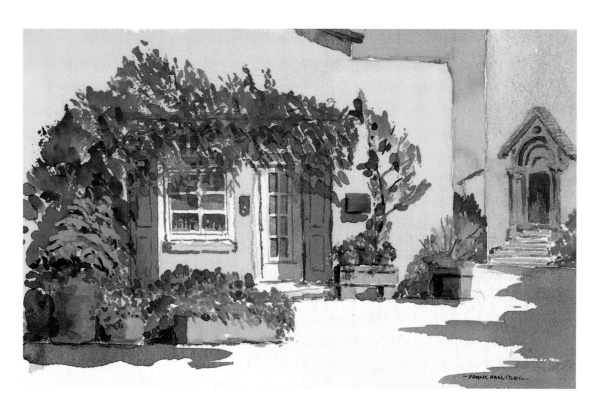

VILLE SUR AUZON, PROVENCE, FRANCE

Everything here is bathed in sunlight, and the door and windows, framed by the vine, make a perfect subject. I quickly sketched the basic shapes and washed in cadmium yellow for the building and the cobalt blue shutters. The panes in the doors were picked out in French ultramarine and burnt umber, and I added interest by indicating shadows. The same treatment was given to the windows. The pots are light red in varying strengths, the vine and potted tubs are cadmium yellow and Winsor blue red shade in different strengths, and the flowers are Winsor red. The church is understated with a wash of raw sienna, so as not to compete for the viewer's eye. The final thing was to bring it all together with shadows – the direction of light is low and strong from the right, as it is early morning. This puts a lovely shadow in the doorway and to the left of the tubs, and the greenery casts dappled shadow on the building.

roofs

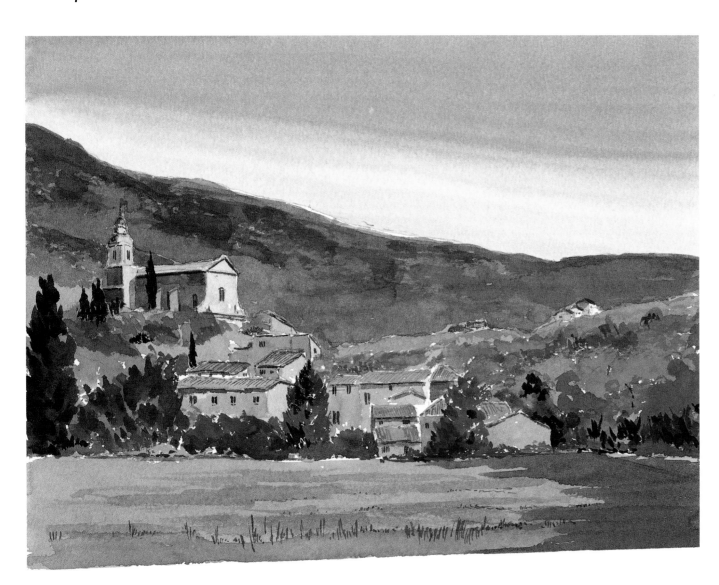

BEDOIN, PROVENCE, FRANCE
In this picture I included roofs going in all directions, a characteristic of this area. With the exception of the church on the hillside, the buildings are far enough away not to cause any problems with perspective. The roofline of the church is going down to the left from the nearest point. The base colour for all the buildings is raw sienna then burnt sienna, raw umber, light red and a touch of French ultramarine.

After washing the buildings with raw sienna I painted the roofs, changing the colours to vary them. When dry, I indicated the directions of the tiles with a darker mix of the same colours. The sky is Winsor blue red shade, and the trees are based on cadmium yellow, French ultramarine and Winsor blue red shade, with Payne's grey in the deep shadows. In this picture light and shade play a major role in giving shape and solidity to the various buildings.

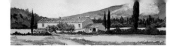

provençal farm

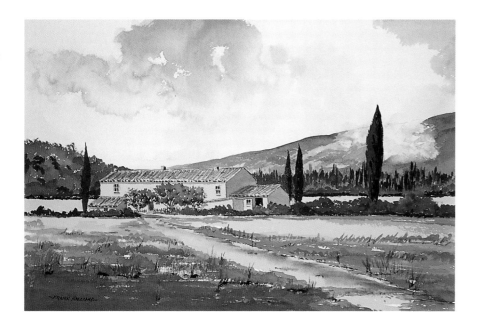

I chose this for the Sunday painting as it will include lots of the things we have covered in the previous projects, but in addition to these, we have an interesting sky and a variety of foliage. You can also practise your perspective techniques with the farm. I have changed the direction of the light from my original view, so that the front of the farm is in full sun. Don't be afraid to change things in your pictures to improve what you are trying to convey. If anything doesn't contribute to the composition, leave it out.

YOU WILL NEED

Colours

- raw sienna
- French ultramarine
- burnt umber
- alizarin crimson
- Winsor blue red shade
- cadmium yellow
- light red
- burnt sienna
- Payne's grey

Brushes

- Nos 16 and 6 round
 (for washes and details)
- 25mm (1in) flat (for
 washes and cornfields)
- Nos 3 and 1 riggers
 (for fine details)

Paper and other equipment

- Winsor & Newton
 Lana Aquarelle Rough
 600gsm (300lb) or
 Winsor & Newton
 Lana Aquarelle Rough
 300gsm (140lb), which
 will need stretching
- Lifting Preparation
- Permanent Masking
 Medium
- soft putty eraser
- 4B pencil

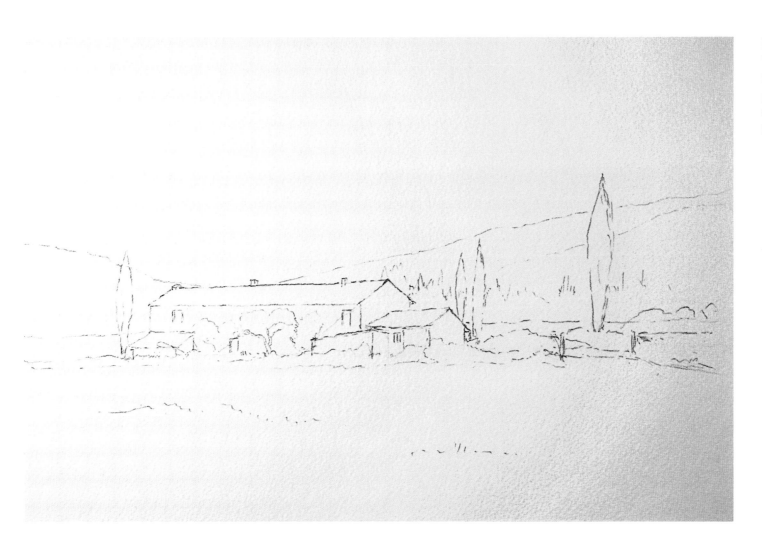

INITIAL DRAWING

This drawing gives you the basic information to paint your picture. I have included lovely tall cypress trees, so evident in this part of the world.

step 1

Using a No. 16 round brush, partially wet the sky with clean water, then paint the sky with a weak mix of Winsor blue red shade, leaving plenty of white paper to create cumulus clouds. In the distance, add a little alizarin crimson to give depth and shadow under the clouds. Run this colour down over part of what will be the background hillside, so that the cloud formation obscures the hill.

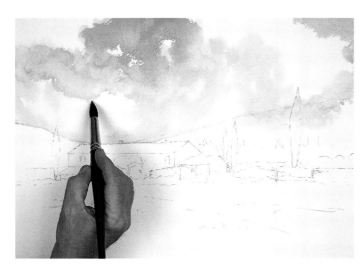

step 2

With French ultramarine and Payne's grey, paint the distant hills, weakening the mix as you go into the distance behind the farm; take care not to paint over the cloud covering part of the hills. Add raw sienna to this mix to suggest fields on the lower slopes. Mix French ultramarine, Payne's grey and cadmium yellow and start painting the conifers to the right, varying the strength of the colour mixes.

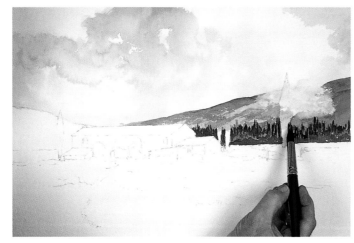

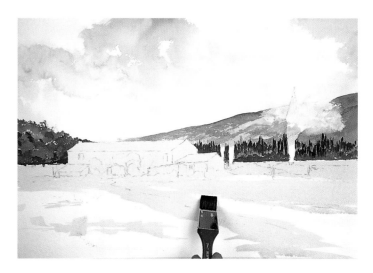

step 3

With the same greens and using a drybrush technique, paint the trees on the left. When dry, use the 25mm (1in) flat brush to wash raw sienna over the background cornfields, farmhouse and foreground area.

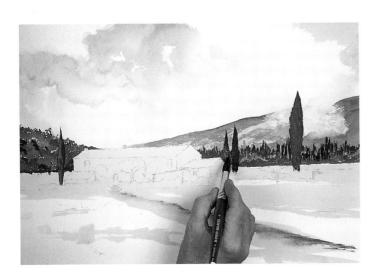

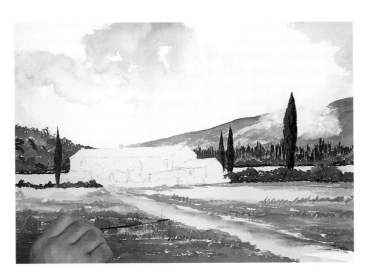

step 4

Using a No. 16 round brush, add detail into the path with French ultramarine and burnt sienna. Mix cadmium yellow and Payne's grey and paint the tall cypresses, using a lighter wash on the left-hand side facing the sun.

step 5

Add the green hedgerow with cadmium yellow and Winsor blue red shade, then paint a little Payne's grey on the underside away from the sun. Weaken the same mix and wash over parts of the foreground to create rough ground. Use a No. 3 rigger to put in some tufts of grass with burnt umber.

step 6

Using the greens already mixed on your palette, add the foliage in front of the farm, and then paint the fence with French ultramarine and burnt umber.

step 7

Mix raw sienna and light red, and paint stripes following the slope of the roofs to make tiles. Add burnt umber for the darker areas under the eaves. Paint the windows using a pale mix of French ultramarine and burnt umber and a No. 1 rigger brush. When dry, put a darker tone of the same mix in the top corners of the windows and the deep shadow in the doorway.

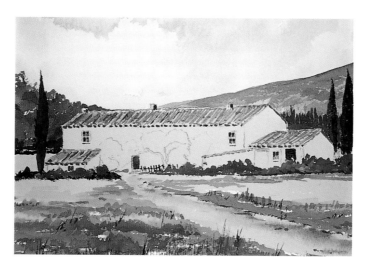

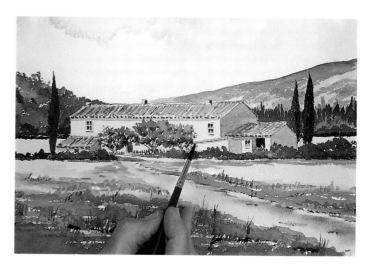

step 8

Mix a leaf green from cadmium yellow and Winsor blue red shade for the foliage in front of the house and apply drybrush with a No. 6 brush, making the right-hand side darker away from the sun. Add the tree trunks in raw sienna, with a touch of French ultramarine on the shadow side.

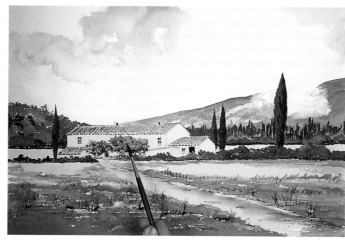

step 9

To introduce the shadows, mix French ultramarine and burnt umber and, remembering that the light is coming from the top left, paint the sides of the buildings. Put in the shadows under the eaves of the roof tops, and also a strip down the inside of the doors and under the windowsills. One of the trees in front of the house casts dappled light onto part of the farmhouse wall.

FINISHED PAINTING

350 x 530mm (13³/₄ x 21 in)

Check over your painting generally and ask yourself, 'Have I missed anything?' – a shadow, a door not painted or a tree without a trunk. When you are sure you are happy and have finished, sign the painting, frame it and hang it on the wall.

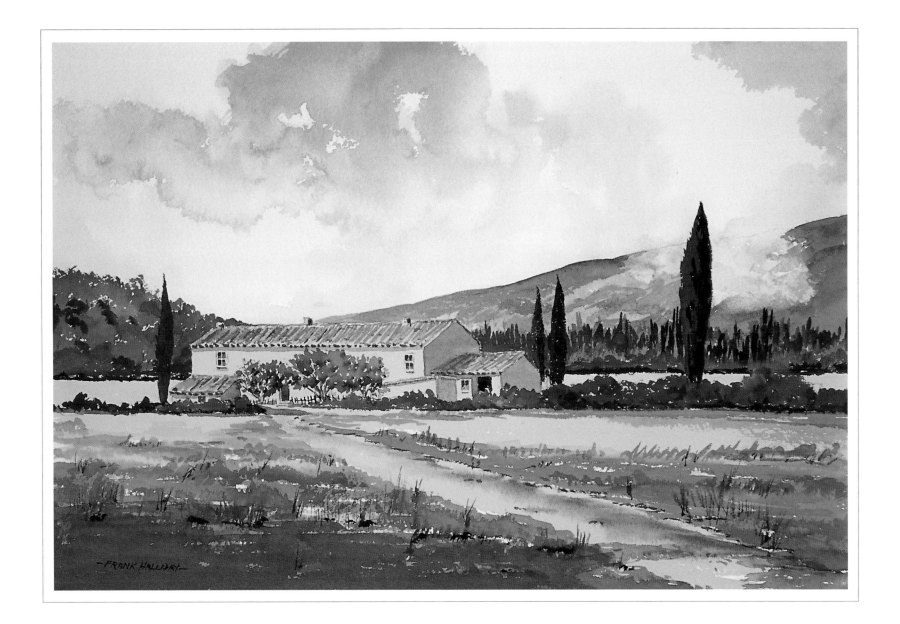

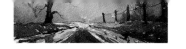

project 6 · reflections

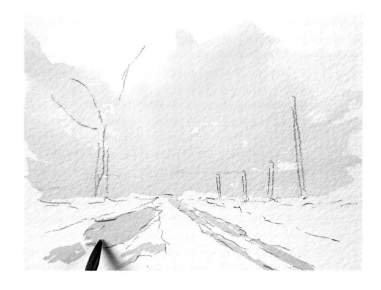

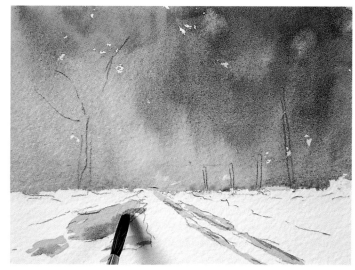

In this section we shall consider reflections in water. I use wet-in-wet techniques for the skies and, most important, transferring the sky colours into the wet areas on the land, which can be a river, a lake, a flooded field or even a puddle on the ground after a heavy rainfall.

When searching for your own subjects to paint, don't be afraid to move the water to a more convenient place in your picture to reflect what you are painting. A good tip is to remember that darks appear lighter and lights darker when reflected in water, and are thus much closer together in tonal value.

exercise 1: puddles on a farm track

step 1

Sketch a few simple guidelines to indicate the lane, tree, fence posts and areas of flooding. After wetting the sky with a wash of raw sienna, pick out the flooded part of the track with the same colour mix and a No. 16 round brush.

step 2

Working quickly, use cobalt blue and light red separately and mixed together in the wet sky. Paint the darker tones in the top right taking care not to lose the glow in the sky created by the raw sienna. Carry these colours into the flooded part of the track.

step 3

While the sky is still wet, use cobalt blue to indicate the distant misty tree shapes. Adding light red to the mix, paint all the trees and shrubs closer to you, with the exception of the main tree on the left. You can slow down now, as you don't need the wet surface. With the same colours, put in the banks beside the farm track, reducing the colour values as you go into the distance. Leave to dry.

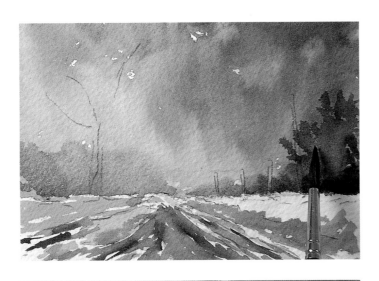

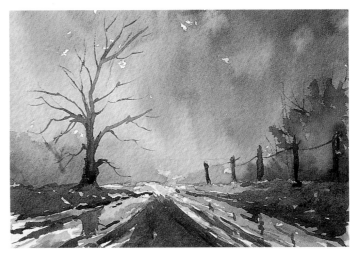

step 4

Switch to a No. 6 round brush and paint the large tree with raw sienna; while still wet put in tones of light red and cobalt blue against the light. Using the same mix, paint in the fence posts and a suggestion of sapling branches in among the right-hand bushes.

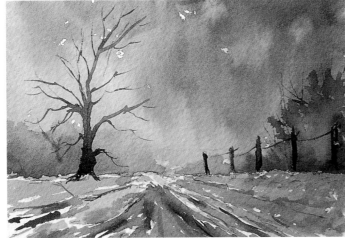

step 5

When everything is dry and using the darks you painted the posts with, indicate shadow areas along the farm track and in the banks supporting the main tree and the shrubs. Finally, pick out the tree and fence post reflections in the flooded track, taking care to ensure that they are directly below the item they are reflecting.

exercise 2: buildings reflected in a flooded field

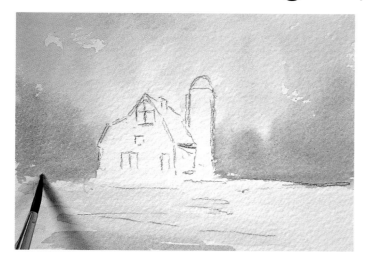

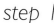

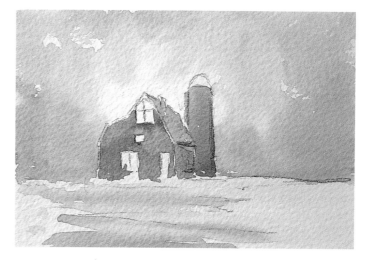

step 2

Add burnt umber to the existing mix to give a grey tone and start painting the barn. The grain store is raw sienna, and while still wet add the grey of the barn colour to the shadow side – in this instance the light is coming from the left and the darker colour will creep around the tower, giving it a cylindrical appearance.

step 1

This is the kind of effect you get when the winter rains more than fill the water table and the water sits on top of the fields at the lowest points. Sketch a simple study of a barn and grain store, placing the building below centre and slightly to the left. Use a No. 6 round brush for the entire exercise. Paint in the sky with Winsor blue red shade, and transfer the same colour into the flooded area of the field. With the sky still wet, add alizarin crimson to the mix and suggest the distant trees. Again, transfer this colour into the flood, because the water will reflect what is above it.

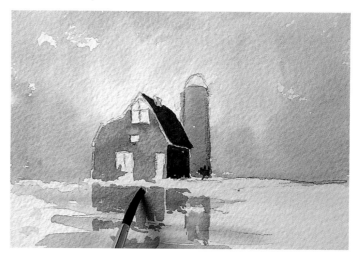

step 3

Using the same colours, place the reflected buildings into the flooded field. Try not to paint an exact mirror image, as this looks contrived and false. A broken, uneven line treatment looks more realistic. Put in the shaded side of the building with a strong mix of the barn colour.

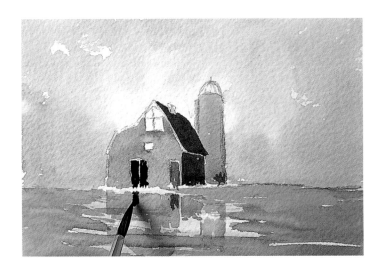

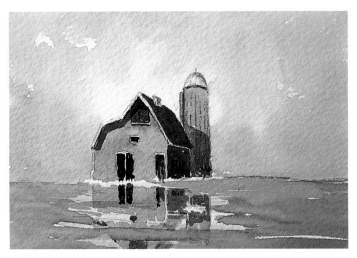

step 5

Use darker tones of the barn front colour to indicate shadows under the eaves. Finish the other windows, and create a little detail on the grain store. Dilute the grey you are using, put a shadow cast by the barn on the tall tower and reflect these extra darks into the flood.

step 4

Add the doors to the barn, repeating their reflection below. Use cadmium yellow with a touch of Winsor blue red shade to create a lovely green that is ideal for the field. Be careful not to lose the reflections you've got by painting too much field colour across the flooded area.

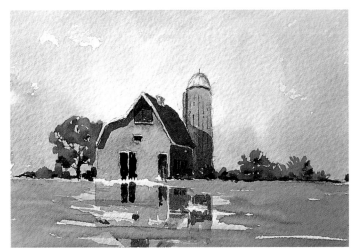

step 6

With a stronger mix of the grass colour from Step 4, paint the hedges and trees, and then use the belly of the brush to drag this into the sky area. Shape the greenery by using the grey of the barn to pick out the shadow sides.

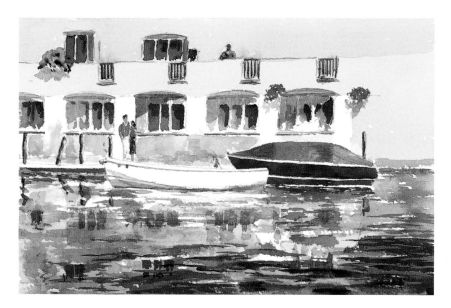

reflected boats

BOATS AT DESENZANO, ITALY

Before I started this picture I coated the water area with Lifting Preparation, which allowed me to lift off the colours later and show the white paper below the paint. I worked on the rear building with raw sienna, and the water was a mixture of French ultramarine and a touch of burnt umber. I painted the windows and lower quayside with a paler mix of the water colour. The dark boat is French ultramarine with Payne's grey added to the lower portion, which I also used for the dark area of water in the foreground. Winsor red is the colour on the white boat and the man's sweater; I coloured the other figure with raw sienna and French ultramarine, and used this for the hanging baskets.

I lifted out the water colour with clean water and a stiff clean brush in the paler areas, and then transferred the tones in the study into the water to create reflections. The light was from the top right, and I painted the angled shadows of the hanging baskets with a paler version of the lake.

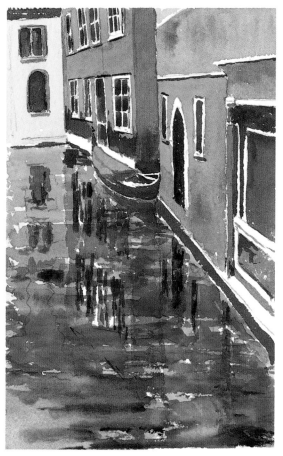

VENICE BACKWATER

I selected a small section of this canal to keep the composition simple. I used masking fluid to retain the areas of white in the water. The buildings from left to right are raw sienna, light red and French ultramarine mixed with burnt umber. As I painted each building, I carried down the colours into the canal, subduing the tones. The gondola and the foreground water, which is reflecting the sky, were painted with French ultramarine and burnt umber, and I used this to pick out the windows. The canal water in the shadow parts gave off a green tone; I mixed French ultramarine and raw sienna to get this effect, and painted it in bands across the reflections.

reflections in a village pond

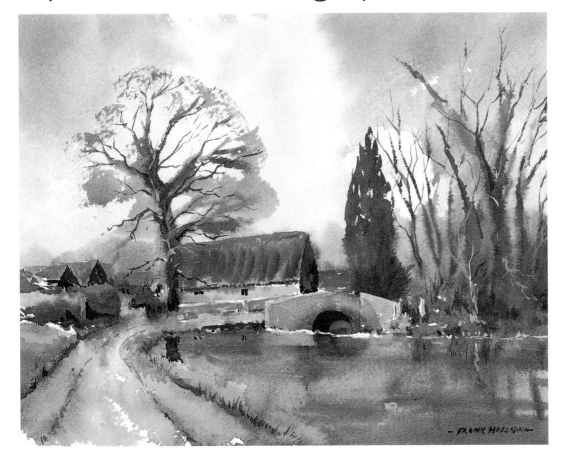

FRING, NORFOLK

On a bright December day, the temperature was hovering just above freezing. The elements dictated that fast work was required before it became too uncomfortable to continue. I quickly sketched a few essential lines of the bridge, barns and road. The winter sun was low and to the left. I painted the sky wet in wet with raw sienna, and then dropped French ultramarine and burnt umber into the wet area. These three colours were then reflected down into the village pond. I put in the background trees with the sky tone. Coming forward, I added more raw sienna to the mix to give a little more warmth, then painted the trees and hedges alongside the pond and put the same colours into the still wet water. I picked out the large tree in raw sienna, and on the shadow side allowed the darker greens to bleed round to give shape. The grasses by the roadside are the same colours as the tree.

I painted the barns with varying tones of burnt sienna and light red, and subdued them in the distance by adding the sky colours. For the bridge I used lighter washes of the barn colours. The reflections of the bridge and nearest barn were shown in the pond. The picture was still wet at this point, and all the colours of the reflections quickly merged into a similar tone.

Back in my studio I painted in the underside of the bridge, the shadow sides of the barns, the large evergreen tree and the detailed branches, then the dark reflections of the trees and the bridge, plus the shadow falling across the bridge. To finish the picture I used a small quantity of white gouache to pick out one or two light-coloured saplings in front of the right-hand trees.

project 6

denver mill

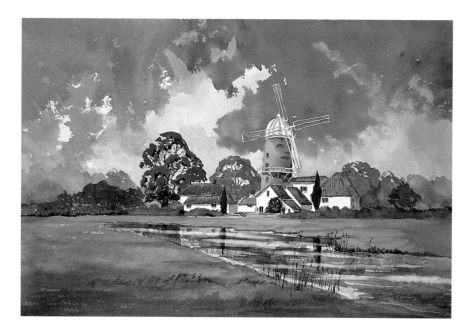

This picture, of a windmill in Norfolk, combines sky techniques and the tips from the Saturday exercises just completed. I changed things around to give a better composition by uprooting several trees that were obscuring the view of the mill. I also joined two small fishing lakes together so that I could use the water directly in front of where I wanted the reflections to be. When out painting, or painting from photographs, look for the direction of the sun to give you the best possible shadows; this gives the lights and darks even more contrast. Move things, or delete objects that do nothing for your picture. Be prepared to change the colour and the texture of buildings and roofs if this gives your painting more punch.

YOU WILL NEED

Colours

- raw sienna
- French ultramarine
- burnt umber
- alizarin crimson
- Winsor blue red shade
- cadmium yellow
- light red
- burnt sienna
- Payne's grey
- Winsor red

Brushes

- No. 16 round
- 12mm (½in) flat
- Nos 3 and 1 rigger (for details)

Paper and other equipment

- Winsor & Newton Lana Aquarelle Rough 600gsm (300lb) or Winsor & Newton Lana Aquarelle Rough 300gsm (140lb), which will need stretching
- masking fluid
- Lifting Preparation
- masking tape
- mapping pen
- soft putty eraser
- 4B pencil

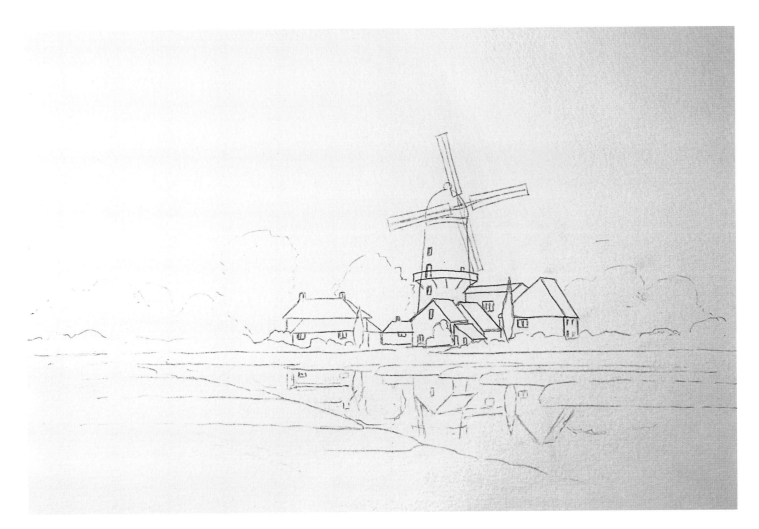

INITIAL DRAWING

I placed the buildings to the right and the horizon one third up the picture plane. This leaves room for the reflections below and sufficient room above for a big sky. If you have problems with the initial sketch, take a piece of tracing paper and cover the sketch on this page and transfer the image. When you are happy with this, cover the back of your tracing paper with shading from a 4B pencil and then place it on top of the watercolour paper. Carefully transfer the lines by going over the image, and you will have a perfect pencil outline to start your picture.

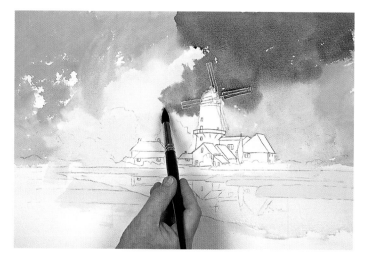

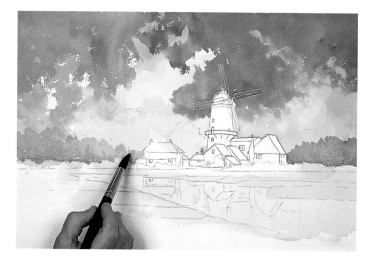

step 2

Work quickly to achieve the best results in the sky, as the horizon area will still be damp. Introduce the two sky mixes as a variety of distant tree shapes.

step 1

Charge a mapping pen with masking fluid and carefully coat the sails of the mill, the edges of its white top where it meets the sky, and the railings of the gantry going around the mill. Paint the lake area with Lifting Preparation. Prepare the three sky colours of raw sienna, French ultramarine and burnt umber. Using a No. 16 round brush, partially wet areas of the sky with clean water and drop in the raw sienna, then paint into the dry areas with French ultramarine and encroach onto the wetted sky. As you go down towards the horizon, add a little alizarin crimson to the French ultramarine, to suggest recession. For the heavy cloud coming from the right, mix French ultramarine and burnt umber to a blue-grey wash of thicker consistency than the wash already on the sky. Make sure the cloud drops down behind the white mill tower to create the strongest contrast.

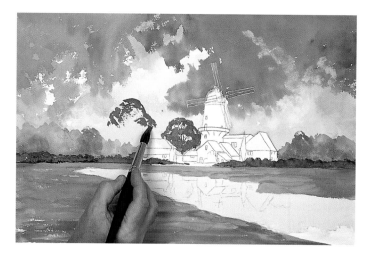

step 3

Wash a mix of raw sienna and French ultramarine across the meadow and indicate more distant trees over the blue ones. Mix cadmium yellow with a little Winsor blue red shade and paint this over the meadow on top of the existing wash. When dry, use the same colour to paint the hedgerow and the surrounding trees. The sunlight is from the left; to show shadows on the under sides of the trees and hedges use a combination of the cloud colour and areas of Payne's grey mixed with cadmium yellow.

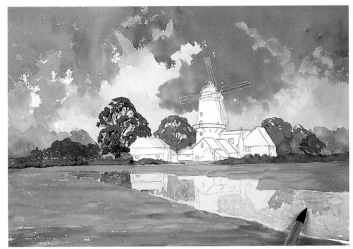

step 4

Continue working on the trees, varying the tones of greens and leaving holes for the birds to fly through. Remember that the cooler, blue-greens will recede in the distance; use the warmer yellow-greens on the trees nearest to the mill, and introduce a couple of small yellow bushes with cadmium yellow. With a No. 3 rigger, paint the gaps in the tree branches with the cloud colour from Step 1 and anchor the whole thing to the ground by painting the trunk. Paint the walk area of the mill with raw sienna, and start dropping the colours of the sky and trees down into the lake for reflections.

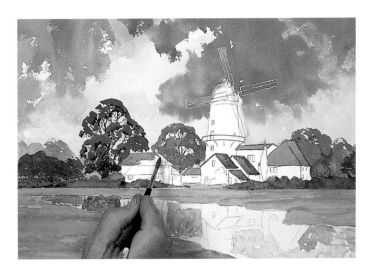

step 5

Mix small separate quantities of light red, burnt sienna and burnt umber to use for the pantile roofs. Using the No. 3 rigger, apply different washes to the roofs to retain interest, and paint the ones nearest to you stronger than the background ones to create recession. These warm red tones are a good complementary combination set against the greens of the trees.

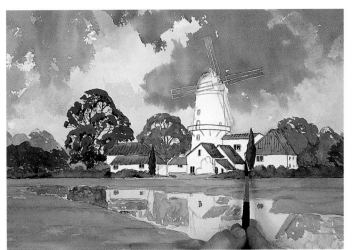

step 6

Indicate a little detail on the roofs with the cloud colour and paint in the windows with the same mix; vary the tones or the building will look derelict. Paint the two conifers with cadmium yellow in the sunlight, and mix it with Payne's grey for a deep dark green in shadow. Show the reflections of the pantile roofs in the water, remembering that dark items appear lighter and light items, darker.

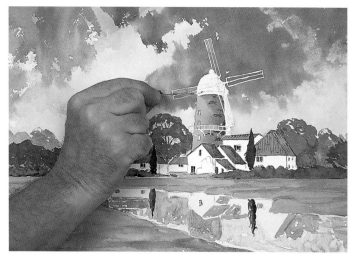

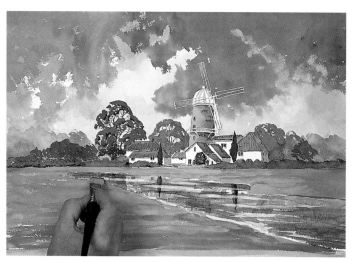

step 8

Paint the small bush in front of the houses, then a variation of sky in the lake as reflections, making the lake darker towards the front. Leave to dry then, with clean water and a clean No. 16 round brush, lift out the highlights for the reflections and dry with a piece of kitchen towel. Use the 12mm (¹⁄₂in) flat brush to give shape to the edges of the lake with burnt umber.

step 7

Paint the reflections of the conifers, then mix a pale wash of burnt umber and paint the body of the mill. While still wet, put some of the cloud colour on the side opposite the sunlight; this will bleed around the tower giving the effect of roundness and solidity. Drop the paler colour into the water. When dry, indicate a few bricks in the tower to show its construction. Paint the strong shadow under the gantry and the windows of the tower. Using the cloud colour, paint over the ends of the buildings away from the sun. Now remove the masking fluid from the sails, the top of the tower and the handrail around the gantry. With a pale mix of the cloud colour, show the structure of the white top of the tower and the shadow sides of the sails and handrails.

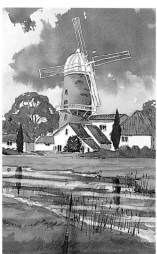

step 9

To create shadow areas across the meadow, with clean water wet more of the meadow than you intend to paint. Quickly drop in a strong mix of the cloud colour, avoiding where the wetted area meets the dry. The shadow colour will be soft at the edge as clouds do not give a hard-edge shadow on the ground. Let it dry, and then with a strong mix of the same colour and a No. 1 rigger, paint a few reeds on the banks. Anchor these to the ground by painting a base of the same colour. Add two small figures against the front building.

THE FINISHED PAINTING
350 x 530mm (13³⁄₄ x 21in)
By using the strong tones throughout the picture and setting complementary colours against each other, and the lightest lights (the white of the buildings is the white of the paper, which sings out its brightness) at the side of the darkest darks, this picture would stand out in any collection. If you want your pictures to have impact and stand out in a crowd, this method can be used for any subject.

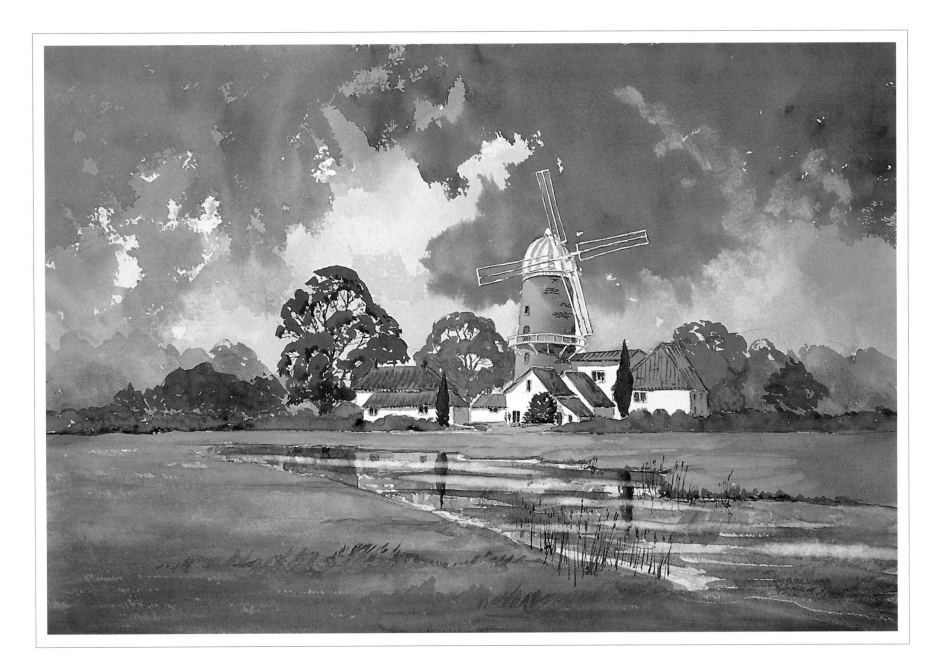

project 7 · winter landscapes

exercise 1: snow-covered tree

Although I paint all year round, my favourite time of year is after the leaves have fallen and when the mists, frosts and snow of winter move in. The colours turn from soft, muted greys on cold, still days to sharp, clear blues when the air is crisp and the sun shines brightly. With snow scenes it is important to remember to exploit the fresh whiteness of the paper to achieve the crispest possible highlights. I tend to paint wet in wet on a smooth paper for misty, moody pictures, and on a rough-surfaced paper for crisp, frosty days, using drybrush to capture hedgerows and branches.

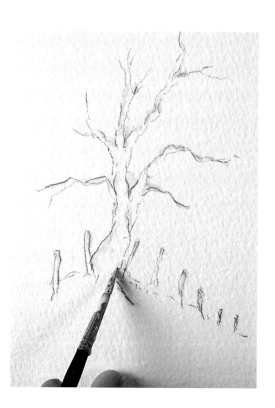

step 1
With a pencil, sketch the winter tree, the rise of the hill and the line of fence posts. Coat an old round brush with soap, then dip it in masking fluid and paint the areas on which snow has settled, then let this dry. Wash the masking fluid quickly out of the brush or it will be impossible to use again.

step 2
Apply a strong, flat French ultramarine wash right down to the shape of the hill with a No. 6. round brush, covering the tree and fence posts. Indicate the shadows from the tree and posts, then leave to dry.

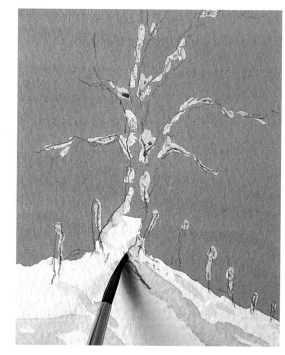

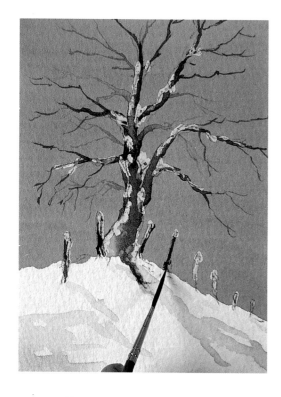

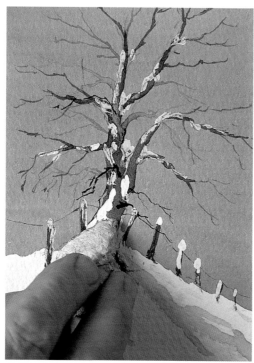

step 3

With a mix of raw sienna, paint in the tree and the fence posts. While this wash is still wet, paint the right-hand sides of the tree and posts with a mix of French ultramarine and burnt umber, using a No. 3 rigger. Blend this wash around the trunk to give a feeling of roundness, then leave to dry.

step 4

Remove the masking fluid from the tree and the tops of the fence posts with a putty eraser.

step 5

With a weak mixture of French ultramarine and burnt umber, paint the right-hand side of the snow areas to depict shadow and to give shape.

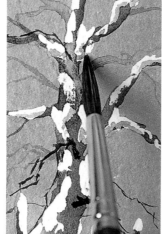

step 6

To give the tree a three-dimensional effect, add one or two branches in a pale French ultramarine and burnt umber mix with the rigger, so they appear to be growing away from the viewer. Use a really strong mix of the same two colours for branches that you want to come forwards.

exercise 2: hoar frost

step 1

Dip a mapping pen with an adjustable nib in masking fluid and draw the shapes of the twigs. Repeat across the paper and then leave to dry. The mapping pen can be used many times as it is metal. When the masking fluid dries on it, it is a simple task to peel it off.

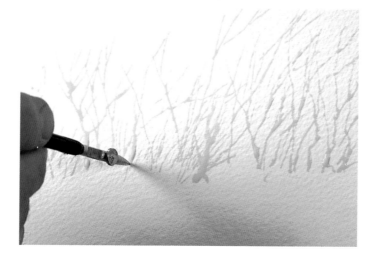

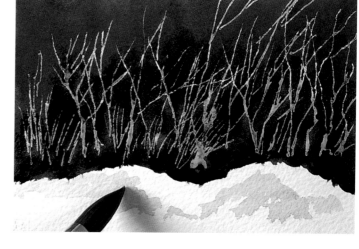

step 2

Using a No. 16 round brush, wash a strong mix of French ultramarine and burnt umber all over the area, except for the snow at the base of the picture. While the sky colour is still wet, drop in raw sienna and burnt sienna to create warmth.

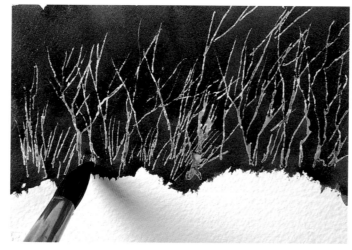

step 3

Indicate shadows on the snow with a light wash of French ultramarine and burnt umber. On this occasion the light is coming from the top right, casting short shadows beneath the trees.

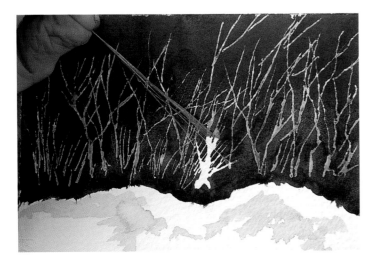

step 4

Pull off the dried rubberized masking fluid to reveal the pure white of the paper, which gives the effect of hoar frost. On the larger twigs, indicate a shadow on the left-hand side to give the twigs an impression of roundness.

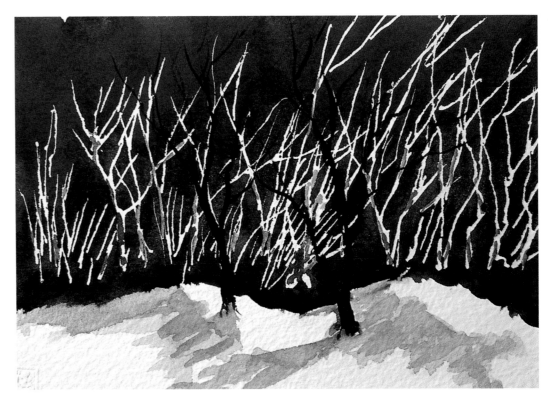

step 5

Mix a strong solution of French ultramarine and burnt umber and paint two darker, small saplings in front of the hoar frost twigs with a No. 6 round brush. To indicate the same direction of light from the right, add their cast shadows across the snow.

shadows on snow

FRESH SNOW

This study attempts to capture an effect of shadows on snow, created by light coming from the top left. I painted the sky with French ultramarine and, while it was still wet, dropped in a stronger mix of French ultramarine for the distant trees, and a mix of burnt umber and burnt sienna for the nearer ones to give a sense of recession. I introduced warmer tones of raw sienna and burnt sienna to bring the sky closer on the right.

As this dried out, I indicated one or two dead or leafless trees to give the picture a bit of interest. On top of this, I painted the fence posts and foreground twigs in raw sienna – at the bases of the twigs in the foreground there is a darker colour, which is an indentation in the snow that creates a shadow effect. The final task was to drop in the shadows behind the fence, and to pick up one or two of the colours with raw sienna and burnt sienna to create areas of ground where the snow has melted.

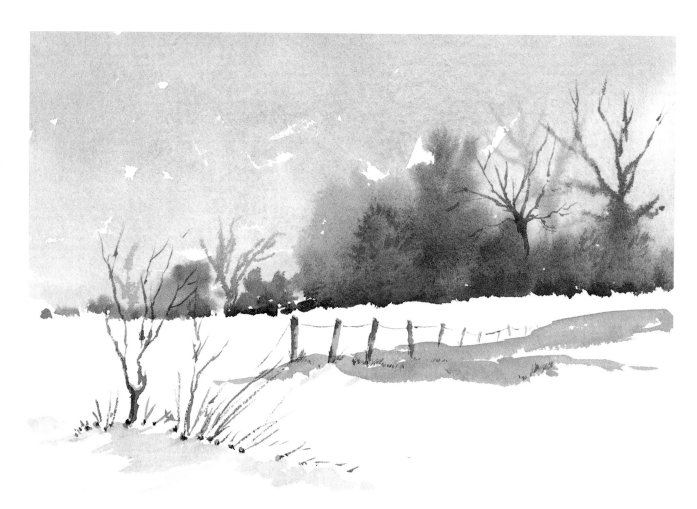

winter evening

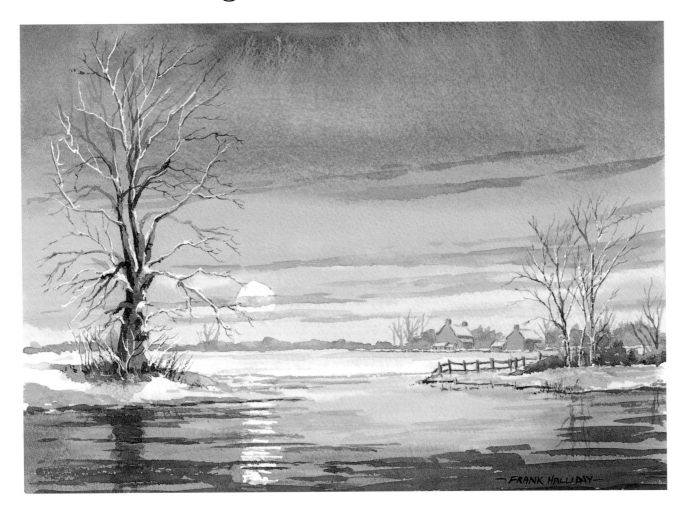

THE WINTER BROAD, NORFOLK

In this winter scene with a sunset, I used a variegated sky technique (discussed on page 16) of warm as opposed to cool colours. I used masking fluid on both sets of trees and the sun (draw around a small coin to get a perfect circle), including its reflection. The sky colours were reflected down in the water and onto areas of the snow, and I also picked out areas on the trees and just a touch on the fence post. I painted the farmhouses and distant trees with a variety of colours used in the sky – raw sienna, Winsor red and, for the darkest part, French ultramarine and burnt umber.

I brought the dark sky down into the nearest part of the water to give the picture recession, and painted the left-hand tree in stronger tones than the right-hand set of trees, because it is closer to the viewer.

winter fields

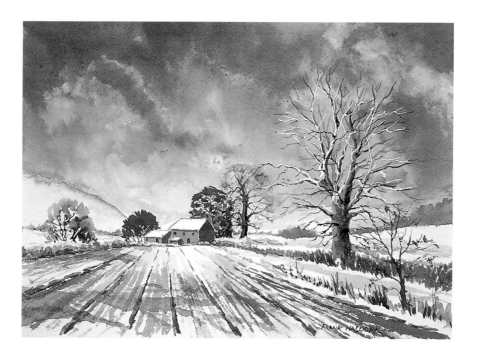

Having flexed your muscles on the Saturday exercises, it's time to start the Sunday painting. Drawing on the knowledge gained earlier in the book on painting skies and trees, this project should be relatively easy. It is a warm winter scene; the furrows of the field and the line of trees all lead to the farmhouse, which is the focal point of the picture. A palette of three colours is used to create harmony – cobalt blue, raw sienna and light red. Linear perspective is also used to depict the ruts in the field and the size of the trees – the nearest one appears to be larger than the others, but it is actually the same size but closer to you. The two darker trees are placed behind the farmhouse to give emphasis to the snow on the roof.

YOU WILL NEED
Colours
- raw sienna
- light red
- cobalt blue

Brushes
- Nos 16 and 6 round (for washes and details)
- Nos 1 and 3 rigger (for fine tree branches)

Paper and other equipment
- Winsor & Newton Lana Aquarelle Rough 600gsm (300lb), or Winsor & Newton Lana Aquarelle Rough 300gsm (140lb), which will need stretching
- masking fluid
- mapping pen
- masking tape
- soft putty eraser
- 4B pencil
- tissue paper

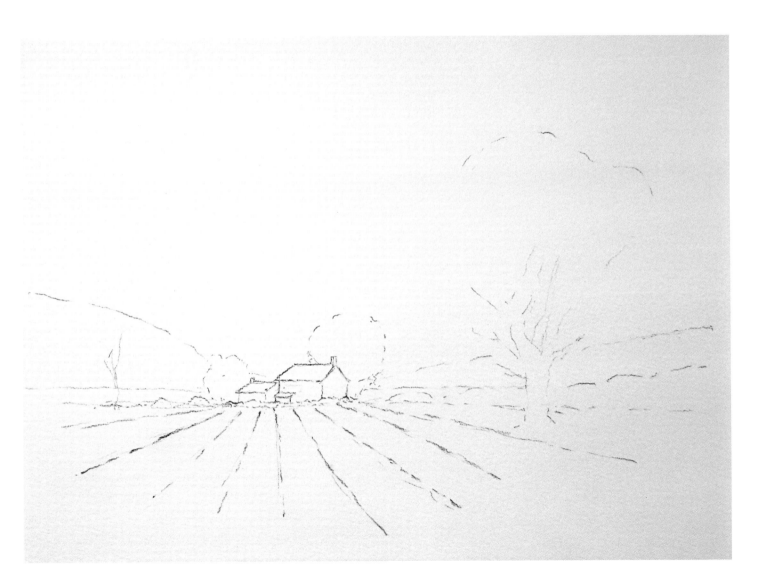

INITIAL DRAWING

It is important to balance the composition. I placed the farmhouse on the convergence of thirds – approximately one third of the way in from the left and one third up from the base – to create a pleasing format. The rutted field lines lead the eye to the farmhouse, and the trees also follow linear perspective towards the farm.

step 1

With the mapping pen and masking fluid, carefully mask out the branches of the trees. Using a No. 16 round brush, paint raw sienna over all the sky area, then, while the wash is still wet, add cobalt blue and a mixture of cobalt blue and light red. Vary the balance between the colours to achieve different tones within the sky area.

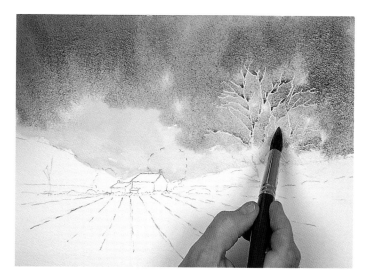

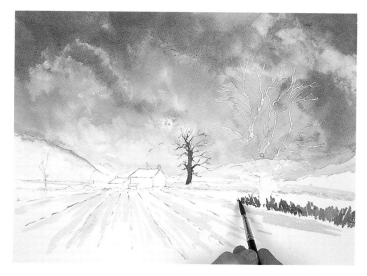

step 2

While the sky is still wet, roll the tissue into a ball and lift out areas of colour to create the cloud formation. This will leave the glow of the raw sienna colour underneath.

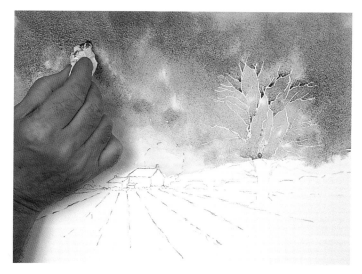

step 3

In this painting the light is coming from the left-hand side; bear this in mind when you are deciding on the values of colours and adding them to your painting. With the No. 6 round brush, paint in the hedgerow on the right-hand side, leaving the top of the hedge white as though snow has settled on it. Then paint the distant larger tree and leave to dry.

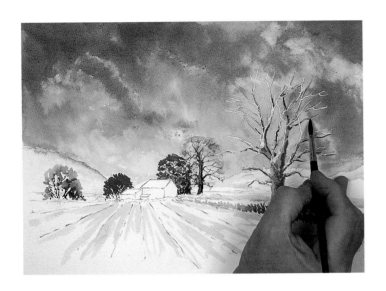

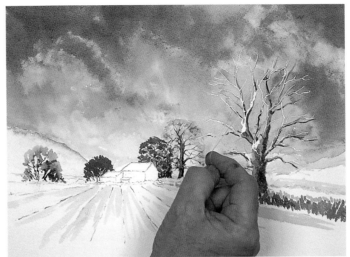

step 5

Use a finger to lift the masking fluid off the large foreground tree – the fluid protects the integrity of the white paper to create the brilliance of snow.

step 4

Paint the two distant trees behind the farmhouse with a mixture of light red and a little cobalt blue, then add fine branches to the distant trees using the drybrush technique. Paint the foreground tree with raw sienna, using an upward motion so the branches appear finer towards the top. While the trunk and the main branches are still wet, drop in the cobalt blue and light red mix in a dark tone, and blend the colours to give the trunk roundness. Continue painting the small branches with light red and a little cobalt blue.

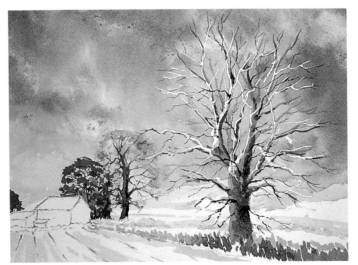

step 6

To depict the shape and roundness of the tree, use a mixture of lighter and darker tones, and shape the areas of white with a pale mix of cobalt blue. Use a No. 3 rigger for these branches and a No. 1 rigger to enhance the finer detail of the tops of the trees.

113

step 7

Using the sky colours, transfer the light of the raw sienna onto the sunlit areas on the snow. For the shadow areas, use cobalt blue with a touch of light red. Paint the farmhouse in light red, and when dry, paint the shadow sides with cobalt blue and light red. Paint the small windows and the farmhouse door with a No. 1 rigger.

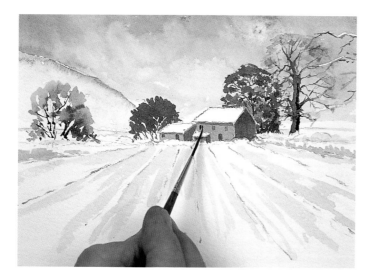

step 8

Make up the details in the hedgerows with the various shadow colours. On the rutted field, use a No. 6 round and the drybrush technique to drag the colours and shadows towards the farmhouse, leading the eye right into the painting.

step 9

Mix a blue-grey from cobalt blue and a little light red, and indicate the shadow areas of the trees, including the shadow across the foreground of a large tree which is off the painting to the left. Use the No. 16 round brush to add shadows, following the contours of the rutted field. Finish off by adding a small sapling at the right in front of the major tree, and put a couple of leaves that seem to hang on there through the winter; using light red gives the effect of a young beech tree.

THE FINISHED PAINTING

250 x 350mm (10 x 13¾in)

Snow is a particularly favourite subject of mine, and this project was a challenge – using only three colours to see how many variations can be made. Although it is a winter scene, the colour combination makes it a warm picture.

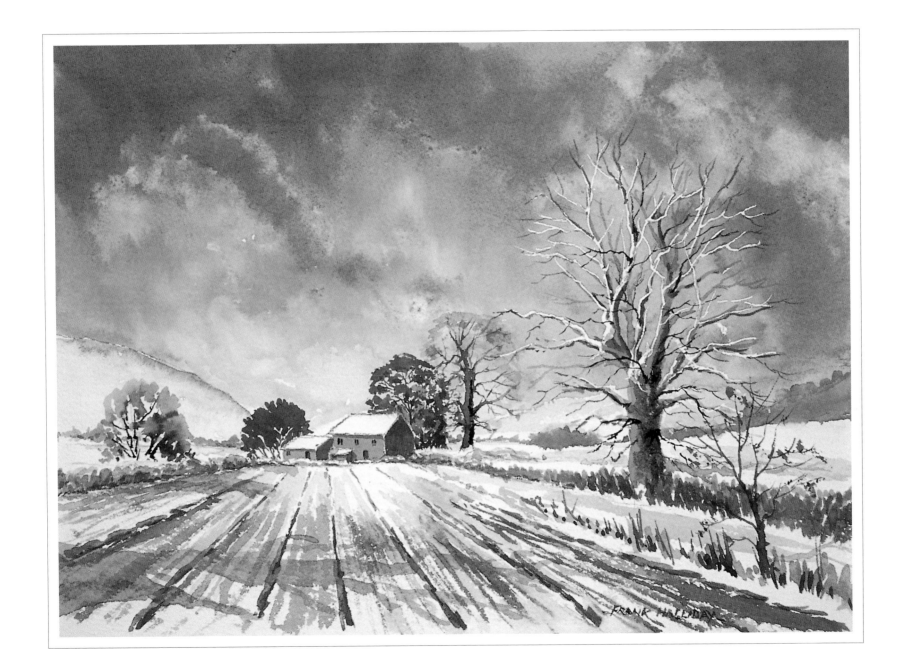

project 8 · summer landscapes

Summer is the time when lots of landscape paintings are attempted because of the better weather, and holidays give us a chance to unwind and try to improve our hobby. In this project I have included typical scenes that you may come across and suggested how to portray them effectively, from a picnic by the river, complete with figures, to cornfields with poppies, boats at low tide, two evening skies and, to finalize this section, a Caribbean beach scene. In summer, more people are out and about, so first are a few notes on figures.

people

DRAWING FIGURES

I would like you to get your sketchbook and take the opportunity to pencil-sketch quick impressions of people doing anything – bending, walking, waving, standing, sitting; you can fill a sketchbook with this exercise alone. When sketching figures, a basic rule of thumb is to make certain assumptions: the groin is roughly halfway down the figure, the kneecap is halfway from the groin to the feet, and the calf midway from the kneecap to the feet. The navel is midway between the groin and the nipple, and the base of the head is midway between the nipple and

the top of the head. This may sound confusing, but if you split the body into quarters, the feet to the kneecap is one quarter, to the groin is another quarter, to the nipple is another quarter, and to the top of the head is the last quarter. Obviously all people are slightly different – some have long legs and some have long bodies – but applying these basic rules should keep you right. I did not draw the small examples on this page, but used a rigger to suggest figure shapes; they are very loose and suggested, but get the message across without fine detail.

summer day

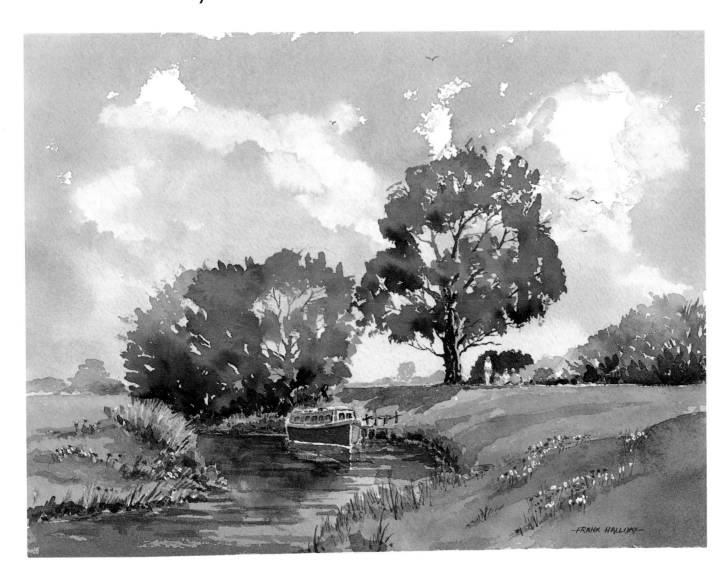

THE PICNIC BY THE RIVER

This was a lovely day for cruising down the river and mooring for a picnic. I washed the central area of the sky with raw sienna, then brushed in French ultramarine, leaving gaps of white paper. The distant trees are French ultramarine and burnt umber, with the mid trees in raw sienna and French ultramarine. Moving forwards, I changed the tree colours, using cadmium yellow and French ultramarine, with the large close tree in cadmium yellow and Winsor blue red shade. I painted the colourful shrubs growing by the picnic site a mix of Winsor red and cadmium yellow, adding alizarin crimson and French ultramarine for the shadowy underside.

The banks of the river are a weak mix of cadmium yellow and Winsor blue red shade, sculpted with the darker greens used for the other trees. For the water I used the colours of the sky with tree reflections added, and the boat was French ultramarine and burnt umber. I flicked in a few reeds with a rigger and added summer flowers to the banks.

117

exercise 1: cornfield

step 1

You can apply this method to any types of flowers in hedgerows. Place a thin strip of masking tape right across your paper just below where you want the sky to come. In the foreground, randomly mask out where the poppies will be with masking fluid (wash the brush out afterwards). Apply a wash of Winsor blue red shade over the whole sky with a No. 16 round brush, starting at the top and working your way down to the masking tape. Leave to dry and then remove the masking tape.

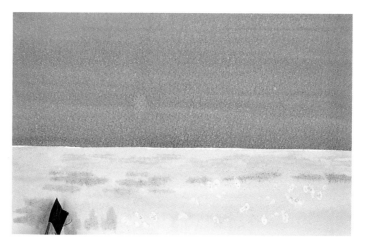

step 2

Wash raw sienna across the rest of the landscape, taking care to avoid the sky. While this is still wet, brush a little burnt umber in fine lines across the wash to represent a darker shade of corn, using a 12mm (¹/₂in) flat brush. This will soften into the wash, but don't overdo it.

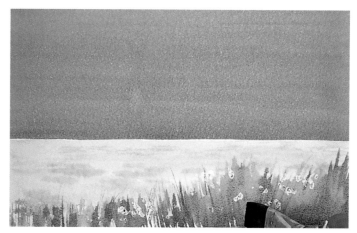

step 3

After this has dried, mix cadmium yellow with a little of the sky colour, then with a flat brush, scrub in the greens at the front edge of the cornfield in an upward movement. Vary the mix strength to add variety, and when dry use a No. 3 rigger to indicate the poppy stems and long grasses.

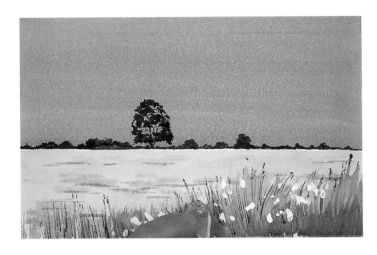

step 4

Make a strong mix of cadmium yellow and Winsor blue red shade and put in the hedgerow across the back of the cornfield along the top of the raw sienna and into the sky with a No. 6 round brush. Vary this green and paint the tree in a drybrush method, placing the trunk and exposed branches with the same colour. Using a putty eraser, remove the masking fluid protecting the poppy heads.

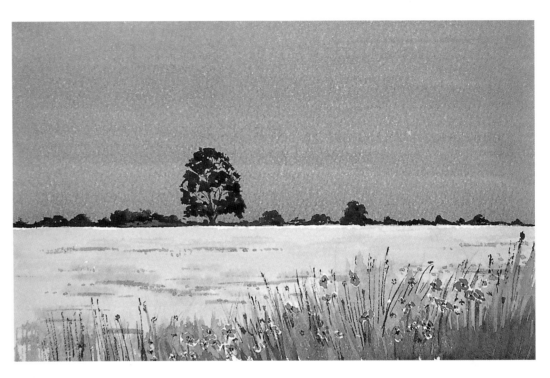

step 5

Using the rigger, paint the poppies with Winsor red so that they are at different angles and sizes, then paint in the dark centres with Payne's grey. I also indicated one or two rogue poppies in the corn where they had escaped crop spraying and added a few cornflowers with cobalt blue, but stopped before I was in danger of overworking the piece.

exercise 2: low tide

step 1

Sketch in the boats and foreground poles, then use a No. 16 round brush to paint the sky with a graduated wash of Winsor blue red shade, streaking across it at an angle. Keep the base of the sky quite light, and take the water from the sky colour. For the distant buildings, add a little burnt umber to the sky colour. Wash the low tide area with raw sienna, and add texture by mixing Texture Medium with burnt umber and painting dark, grainy shapes in the foreground mud with a No. 6 round brush.

step 2

Use a No. 3 rigger to paint the distant boat, using a weaker shade of the distant building colour from Step 1. Add the main boat with burnt sienna, and on the underside shape the hull with burnt umber; use this colour for the furled sails against the light. Then paint the reflections of both boats using similar colours. Switch to a No. 1 rigger for the finest details.

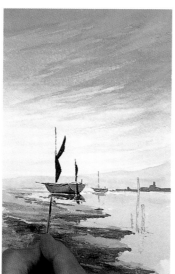

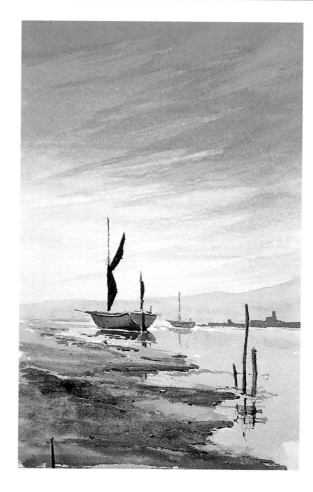

step 3

Vary the length and thickness when you paint the three poles in the foreground with the No. 6 round brush, or they can appear too uniform. These are also reflected in the water, so indicate some movement at the water's edge to break up the reflection. Tighten up the darks at the mud line, and also put in darks towards you away from the light source. Look for interesting shapes in the mud and turn them into flotsam, then use a rigger to paint a few pebbles and stones close to hand to finish.

summer evening

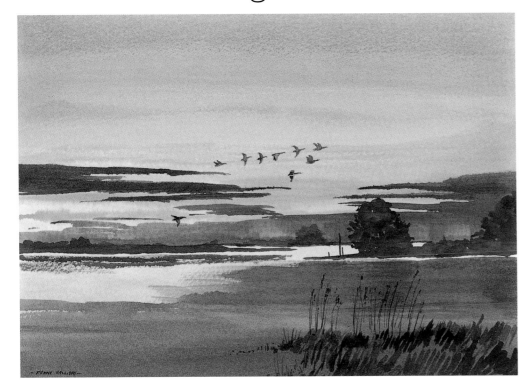

FLYING HOME TO ROOST

This is an area close to my home called the Norfolk Broads. I painted it as the last light was fading, with the sky colours pre-mixed, ready to complete in one go and continue the colours into the water. I used French ultramarine and burnt umber coming down to Winsor red and a touch of cadmium yellow, finishing with raw sienna, all painted wet in wet and reversed for the reflection in the water. I allowed the sky to dry and, with a strong mix of French ultramarine and burnt umber, painted the distant hedgerows and trees as silhouettes, and added a few grasses with a rigger. Using the sky colours on the palette, I painted some low, dark, distant clouds increasing as the night was approaching. The flight of geese, with one trying to catch up with the others, was the last thing I painted.

FINISHED FOR THE DAY

Here again, calmness is the theme with boats at anchor and the sun setting over a harbour. I masked out the sun and the line of reflection with masking fluid and washed the picture all over with raw sienna. While still wet, I streaked burnt umber across the sky, which softened into the original wash, then simply stated the silhouetted boats with pale French ultramarine and burnt umber. With the same two colours but much stronger, I painted in the harbour wall and the low tide mud, avoiding the light from the setting sun. I removed the masking fluid and introduced raw sienna and burnt umber into the strip of reflection.

lower bay, bequia, grenadines

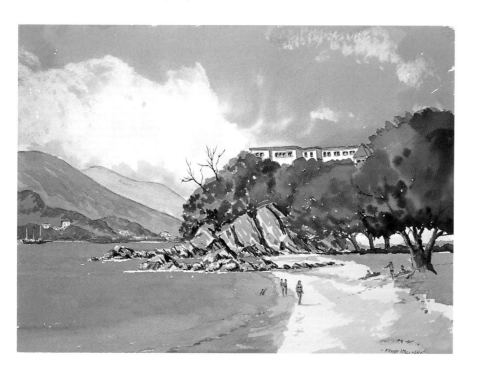

We are now at the last Sunday project in the book, and I hope you have enjoyed sharing the trips to various parts of the world. This one is no exception – it is a small jewel of an island that I had the privilege of visiting, and its warm climate and friendly people put it high on my list to revisit. In this picture I have included what we have covered earlier in the book – skies, water, mountains, trees, rocks, buildings and, of course, people.

YOU WILL NEED

Colours

- raw sienna
- cadmium lemon
- cadmium yellow
- Payne's grey
- burnt umber
- alizarin crimson
- light red
- French ultramarine
- Winsor blue green shade
- Winsor blue red shade

Brushes

- No. 16 round (for large areas)
- No. 6 round (for general detailed work)
- No. 3 rigger (for fine details)

Paper and other equipment

- Winsor & Newton Lana Aquarelle Rough 600gsm (300lb) or Winsor & Newton Lana Aquarelle Rough 300gsm (140lb), which will need stretching
- 4B pencil
- tissue paper

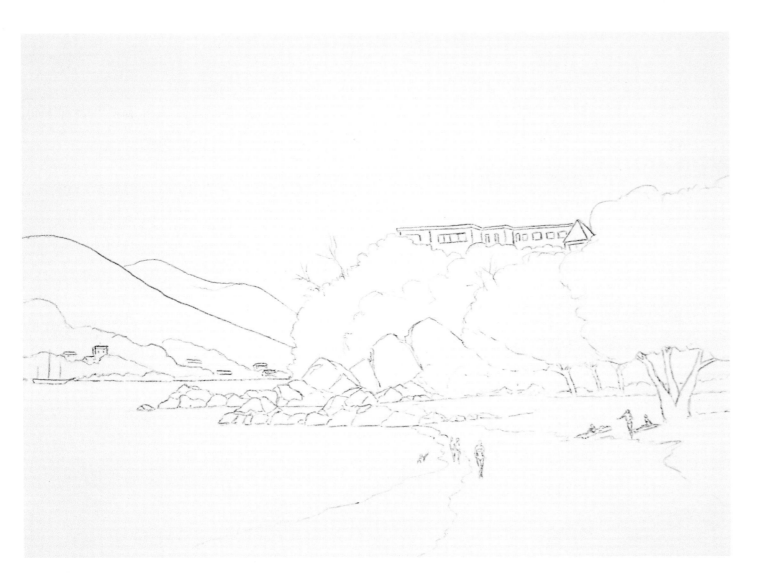

INITIAL DRAWING

Use a 4B pencil to lightly sketch in the full details to complete the picture. This ensures that objects are in harmony before you commence the painting.

step 1

Use a No. 16 round brush to wash raw sienna over the sky, the rocks and beach, then paint in the sky with Winsor blue red shade, lifting out cloud formations with a tissue. Add a little alizarin crimson to the blue mix and introduce it into the bottom of the sky.

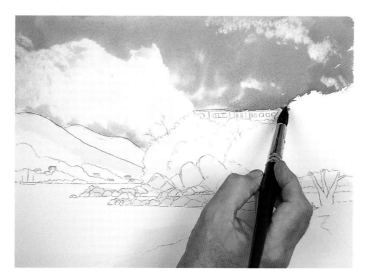

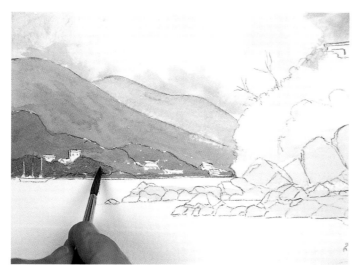

step 2

When dry, switch to a No. 6 round brush to paint the distant hill with the darker sky mix, introducing raw sienna to the mix to make the next hill greener. Then, using cadmium yellow and a little Winsor blue red shade, paint the near hills. Leave to dry and use the same mix to shape and sculpt the contours on the hillsides.

step 3

With a weak mix of light red, paint in the distant houses among the hills. Using a mix of cadmium yellow and Winsor blue red shade and a No. 16 brush, start painting the trees on the headland with the house on top. Vary the shades of green and add Payne's grey to make juicy deep greens in the shadows underneath. In this part of the world, close to the equator, shadows are sometimes directly below the objects. Paint the rest of the trees on the beach using the same greens, with the tree trunks in the very dark green silhouetted against the bright sand.

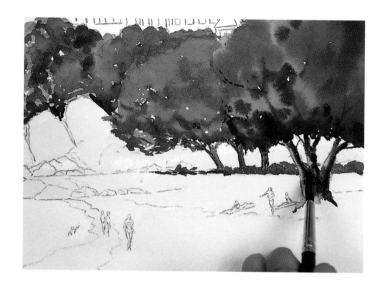

step 4

Paint the front tree trunk in raw sienna, and while it is still wet use the dark green to give the three trunks shape. Using cadmium yellow and Winsor blue red shade, add the hedgerow along the back of the beach.

step 5

Try to make the rocks along the end of the beach look three-dimensional – start with raw sienna in different strengths, and then add weak burnt umber, then French ultramarine to get a deep shadow colour that would be evident on a bright day like this.

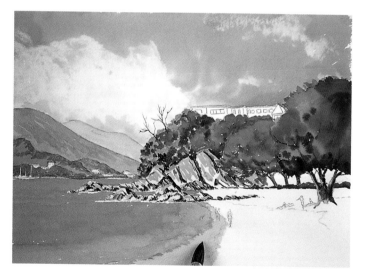

step 6

For the sea, start at the horizon with Winsor blue green shade, working down with the wash towards the beach near the edge where the underwater sand in the shallow water affects the colour. To achieve this difference, add a little cadmium lemon to the mix. Allow to dry and then wash a weak mix of burnt umber along the edge of the water to give the impression of wet sand.

step 7

Add more detail to the beach where people have walked and give the impression of the sand sloping towards the sea. Paint the roofs with light red using a No. 3 rigger. Mix French ultramarine and burnt umber, and use the same brush to paint in the windows facing the bay. When dry, put dark areas of shadow top left of the windows. Weaken this mix a little to indicate the windows in the houses across the bay.

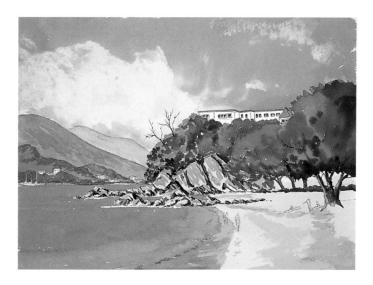

step 8

Paint in the figures using the rigger and a weak light red wash for the tanned skin tones. Use a variety of bright sunny colours for the beachwear and towels. Have the figures doing things such as talking, sitting down on towels, standing half-submerged in the sea and waving to someone on the beach.

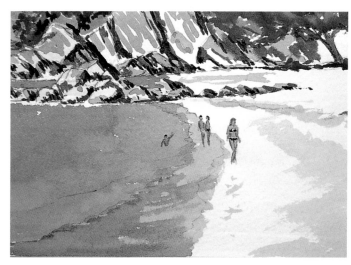

step 9

Mix French ultramarine and burnt umber and, starting with the house on the hill, put the right-hand sides in shadow along with the underside of the roofs. Moving down the picture, put shadows in amongst the rocks. The sun is high, and this requires strong shadows under the trees. Finally, check round your picture to see if you have missed anything – I had missed the schooner at anchor in the bay, so I quickly painted it in using a little of the light red I had left.

FINISHED PAINTING
250 x 350mm (10 x 13³⁄₄in)
I hope you have managed to capture the essence of this scene, in which I tried to convey the light and warmth of the Caribbean – I am certainly planning to go back!

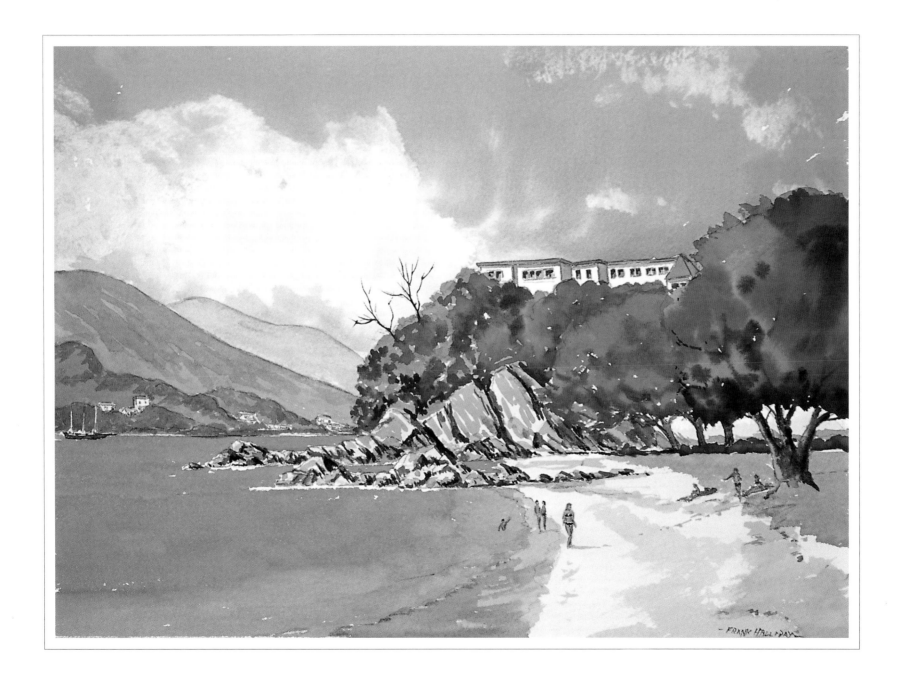

index

acknowledgments

My thanks to:
Freya Dangerfield, Senior
Editor; Brenda Morrison, Art
Editor; Sarah Hoggett, for
asking me to do the book in
the first place; and the
terrific, friendly team at
David and Charles.